So Incredibly Idaho!

SO INCREDIBLY IDAHO!

SEVEN LANDSCAPES THAT DEFINE THE GEM STATE

CARLOS ARNALDO SCHWANTES

UNIVERSITY OF IDAHO PRESS
Moscow, Idaho

Published by the University of Idaho Press
Moscow, Idaho 83844-1107
All rights reserved

Design by Caroline Hagen
Map by Allan Jokisaari

Printed in China through Palace Press International

All photographs by the author, except where otherwise noted.

00 99 98 97 96 5 4 3 2 1

Library of Congress Cataloging-in-Publication Data

Schwantes, Carlos A., 1945–
 So Incredibly Idaho! : seven landscapes that define the gem state / Carlos Arnaldo Schwantes.
 p. cm.
 Includes bibliographical references (p. 135) and index.
 ISBN 0-89301-193-2
 1. Idaho—Pictorial works. 2. Landscape—Idaho—Pictorial works.
3. Landscape photography—Idaho. I. Title.
F747.S39 1996
917.96'0022'2—dc20 95-26340
 CIP

Contents

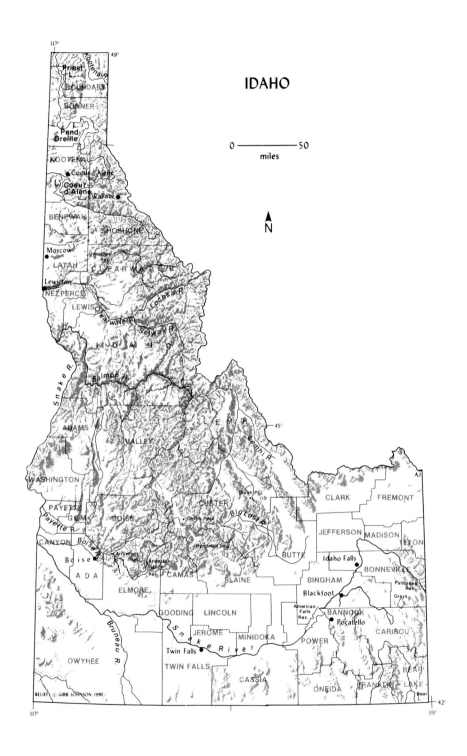

IDAHO

0 ———— 50
miles

N

Priest L.

BOUNDARY

BONNER

L. Pend Oreille

KOOTENAI

Coeur d'Alene
L. Coeur d'Alene
Wallace

BENEWAH

SHOSHONE

Moscow

LATAH

Dworshak Res.

CLEARWATER

Lewiston

NEZ PERCE

Lochsa R.

LEWIS

Clearwater R.

Selway R.

I D A H O

Snake R.

Salmon R.

ADAMS

VALLEY

L E M H I

Lemhi R.

45°

WASHINGTON

Borah Pk.

CLARK

FREMONT

PAYETTE

GEM

Payette R.

BOISE

CUSTER

Cache Peak

BIG LOST R.

JEFFERSON

MADISON

TETON

CANYON

Boise R.

Arrowrock Res.

Anderson Ranch Res.

Pyramid Pks.

BUTTE

Idaho Falls

BONNEVILLE

Boise

ADA

CAMAS

BLAINE

BINGHAM

Blackfoot

Palisades Res.

Grays L.

ELMORE

GOODING

LINCOLN

American Falls Res.

BANNOCK

Pocatello

CARIBOU

Bruneau R.

Snake River

JEROME

MINIDOKA

POWER

Twin Falls

OWYHEE

TWIN FALLS

CASSIA

ONEIDA

BEAR LAKE

FRANKLIN

Bear

RELIEF © GIBB JOHNSON 1990

117°

49°

117°

45°

111°

42°

Illustrations

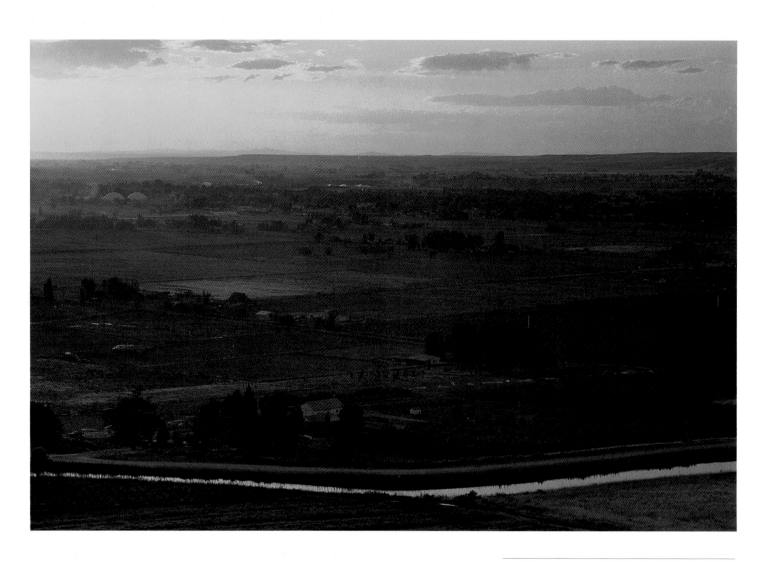

The setting sun burnishes irrigated fields west of Emmett in August 1994.

PREFACE AND ACKNOWLEDGMENTS

CHANCE HAPPENINGS ENLIVEN everyday existence: an unreturned phone call, wrong directions, or a lost key can all heighten emotions and produce unintended consequences. In my own life fortuity has inspired new book projects and even launched new phases of my career as a historian. I almost ruined my first opportunity for full-time college teaching by shoving a letter of initial inquiry deep into the pocket of my winter coat and then forgetting about it until weeks later. Despite chronic absentmindedness, I got the job, which in turn introduced me to the Pacific Northwest, where I have lived without regret since 1969. *So Incredibly Idaho!* is itself a tribute to the influence of the fortuity factor.

Jacques Barzun once noted that writers have historically used a variety of odd devices to liberate their creative impulses. Mark Twain liked to write in bed; the German poet Schiller required the smell of apples rotting in his desk. For other writers the list of inspirational devices included cats, horses, pipes, silk dressing gowns, exotic headgear, whips, beverages and drugs, and hair shirts. Being of simpler mind and character, I prefer to prod my creativity with long drives down country roads or travel aboard boats or trains. Even an intercity bus trip will do. I started one book project aboard Amtrak's San Francisco Zephyr during a journey from Omaha to Salt Lake City and began another aboard ship on the Columbia River.

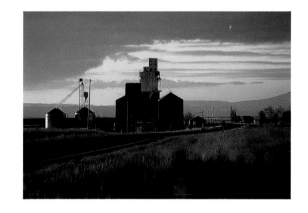

The warm light of a November sunset reflects off grain elevators at Fenn on the Camas Prairie, 1993. Highway 95 crosses this productive agricultural region from Winchester to Grangeville.

Inspiration for *So Incredibly Idaho!* came one tempestuous evening aboard a bus bound from Moscow to Boise. By air I could have covered the three hundred miles in little more than an hour (and usually do when I'm in enough of a hurry to travel that way). But this time the eight-hour bus ride offered me an escape from daily interruptions and the chance to grade a set of overdue papers. Mainly, though, I wanted to indulge a half-remembered childhood fantasy: once I fashioned a whole fleet of Greyhound buses from animal cracker boxes, and I still enjoyed viewing the passing countryside from the elevated perspective of a bus window.

A winter storm added unexpected excitement to the otherwise routine trip. Gusting winds buffeted the big coach, lifted a few of McCall's Christmas decorations from their support wires and smashed them to the pavement, and knocked out electric power to communities all the way to Horseshoe Bend. Curiously, the long ride through darkest Idaho untethered my thoughts and sent them spinning off in unanticipated directions. I spent the remaining miles by constructing in my mind an explanation of Idaho, my adopted home, for friends back East.

For most of the day I had been on my way to Boise, traveling on the same bus from the site of the state's oldest public university to its capital; yet during the long journey I had not passed through a single community of more than 28,000 inhabitants. Most settlements were mere hamlets or villages: Cottonwood, Fenn, Cascade, Smiths Ferry, and the like. I had crossed one county which covered nearly twice the area of Connecticut but where the law enforcement establishment could for all practical purposes hold a conference in a patrol car or two. The average Idahoan's aversion to gun control can be explained in part by the peculiar spatial relationship created when a few people are surrounded by an enormous expanse of empty space, as people are all over Idaho.

The West as a whole has often been described as a state of mind, but Idaho is more than anything else a state of *space.* Our perceptions of spatial relationships influence much that we Idahoans think and do; they define our sense of place. When we fret about too many people moving to Coeur d'Alene or Boise (as we often do in recent times), we usually frame our complaints in terms of altered

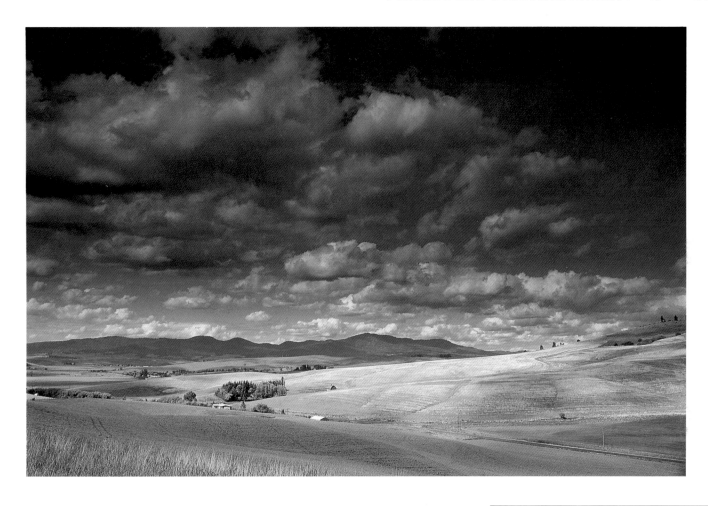

Idaho space: an expansive agricultural landscape east of Moscow, June 1994.

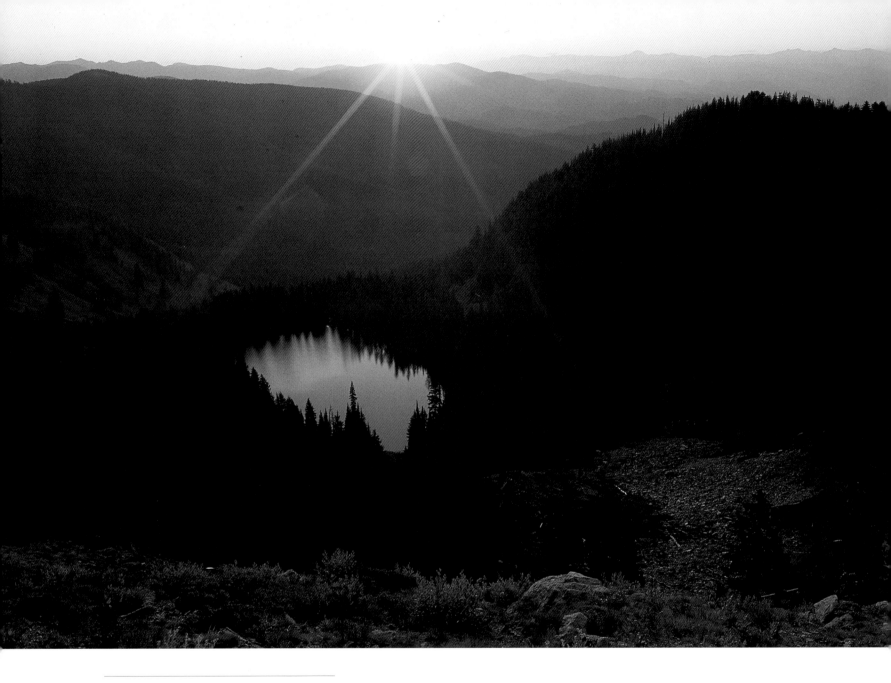

Sunrise at Post Office Lake, August 1992. The Lewis and Clark Expedition followed an Indian trail near here to surmount the Bitterroot Mountains in 1805–6.

space, of shade trees cut down to widen increasingly crowded boulevards, and of the proliferation of subdivisions that we invariably compare to Los Angeles. We ignore the fact that most of Idaho's vast landscape remains virtually untouched by population growth.

Back in the more compact spaces of Indiana and the Midwest where I grew up, an eight-hour bus trip would have taken me from Indianapolis to Chicago and back, and still allowed enough time in the Windy City for a quick lunch. Or I could have traveled by train from Chicago to Cleveland or Kansas City. As I sat in the darkened bus as it crested the last ridge before Boise, I reflected on Midwestern states where the oldest public university was located within an hour's drive of the capital and major population centers. Indiana University in Bloomington is an easy drive from Indianapolis; the University of Minnesota is within the Twin Cities metropolitan area; and the University of Wisconsin, where I spent one summer in research, is located only blocks from the capitol building in Madison.

The placement of the University of Idaho in the state's remote northern panhandle is a prime example of how an overwrought sense of space contributes to sectionalism and influences political decisions in Idaho. The spatial relationship between university and capital resulted from the most important Presidential signature *that never was* (at least from an Idahoan's perspective) and is perpetuated by no less an authority than the state's own constitution. I'll explain this curious matter in detail later. It is one of many topics I want to ease into after a proper introduction.

When pondering differences between East and West I often return in thought to several experiences of camping out with my students on the Lewis and Clark trail in the Bitterroot Mountains. In some locations we were fifty miles from the nearest phone, and at twilight, when the first stars appeared and only the profiles of distant mountains were still visible, I beheld almost exactly what Lewis and Clark had viewed nearly two hundred years earlier. That was still possible along only a few other parts of their route from Saint Louis to the mouth of the Columbia River. Where could I go in the Midwest or the East to see the same landscapes people saw in 1804 or 1805? Perhaps only to a few historic parks and

shrines. So much of the land back there has been tamed and so many places cribbed and confined to the point of artificiality—consider how Plymouth Rock had to be enclosed to prevent vandals from chipping it away for souvenirs.

True, it is still possible to experience both nature and seemingly empty space in the Appalachian Mountains of West Virginia, the Adirondacks of upstate New York, the remote upper peninsula of Michigan, and numerous other rural locations. However, during a vacation trip back to the East Coast a few summers ago when I made a point of asking people what they would recommend most about their hometowns, they almost always emphasized artificial places and confining spatial relationships. Invariably their choices were tame and uninspiring enough to turn the stomach of a true Idahoan.

One evening at a motel in Asheville, North Carolina (a crossroads city of the modern South), I posed my question to several fellow travelers. One woman bragged that Cincinnati was close to Kings Island, a gargantuan amusement park. Then, pausing a moment for reflection, she added that her hometown also had a fine Saks Fifth Avenue store. Somehow that seemed a little like inviting a friend from New York City to visit Boise primarily to sightsee at the Towne Square shopping mall. A man from Myrtle Beach, South Carolina, emphasized golf courses and condominiums. He neglected to mention the beautiful white beaches I recall from the Myrtle Beach I visited as a child nearly fifty summers ago.

If I were to put that same question to Idahoans, I'm certain most would mention the great outdoors that crowds the edges of even our largest population centers. Many people might also emphasize the still relatively pristine quality of so much of our state's natural setting. In fact, I personally believe the defining quality of life in the Gem State is that we million Idahoans still have ample open space surrounding us and plenty of opportunity to commune, both collectively and individually, with nature as it existed before humans attempted to reshape it, as they have done so relentlessly and successfully in the trans-Mississippi East.

Untamed nature in the form of mountains is the essence of an Idaho panorama. So much of the state's surface is uplifted into lofty peaks that mountains are visible from virtually everywhere. They not only signify undomesti-

Sportsman Access on Idaho 28 north of Mud Lake, July 1992. "In northern Idaho," observed the Boston Globe *in 1995, "the people revere the outdoors like New Yorkers worship Wall Street." The same is true for all of Idaho.*

cated space but also contribute to the irregularity of natural and cultural land-scapes in every part of Idaho. Except mainly along the Snake River plain, where rectangular fields of potatoes, sugar beets, and grain extend to the horizon, Idaho still has the appearance of being rough and unfin-ished. Apart from state boundaries and city streets, straight lines are an uncommon feature of our 84,000 square mile landscape.

When crossed by automobile, Idaho's space can over-whelm the impatient motorist. But the same immense landscape can be emotionally exhilarating to a person who will take time to experience it fully. I've learned to slow down and enjoy all I can survey from a car window, no matter how many times I've driven the same road. Different seasons or times of day alter any panorama by intensifying colors or contours to reveal anew both the spectacular and subtle aspects of Idaho's space.

Lured by curiosity that borders on passion, I've trav-eled to every one of Idaho's forty-four counties. Not content to stop at the state's borders, I extended my ex-plorations through neighboring states until finally I had reached all but one of the counties located on or west of the hundredth meridian, the mental divide between East and West, the line sep-arating the wet and dry halves of the United States. There are 632 counties in this group (including the largest, San Bernardino in California, which covers more ground than any of nine small states). The only one I skipped was Bullfrog County, Nevada, which in my 1988 *Hammond World Atlas* has neither roads nor population centers. It apparently has no legal existence either.

I didn't go to these counties merely to check them off a list. I wanted to study them by paying close attention to the things residents unintentionally reveal about themselves and where they live, by gathering information that eludes most formal histories. My tools were a camera, notebook, pocket tape recorder, and relevant history and travel books, including old and new roadside guides. Upon

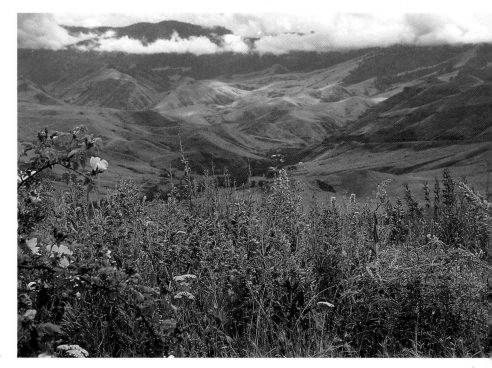

Spring wildflowers—purple beardtongue, white yarrow, and wild rose—crown the top of old Whitebird Grade, June 1993. Often when wea-ried by the prospect of climbing Whitebird Grade for the umteenth time, I choose the narrow and winding old road, which in June weaves its way through natural gardens like this. The beauty, and especially the fragrances, offer an intimate, even sensual, way to experience the Gem State which no book alone can ever hope to replicate.

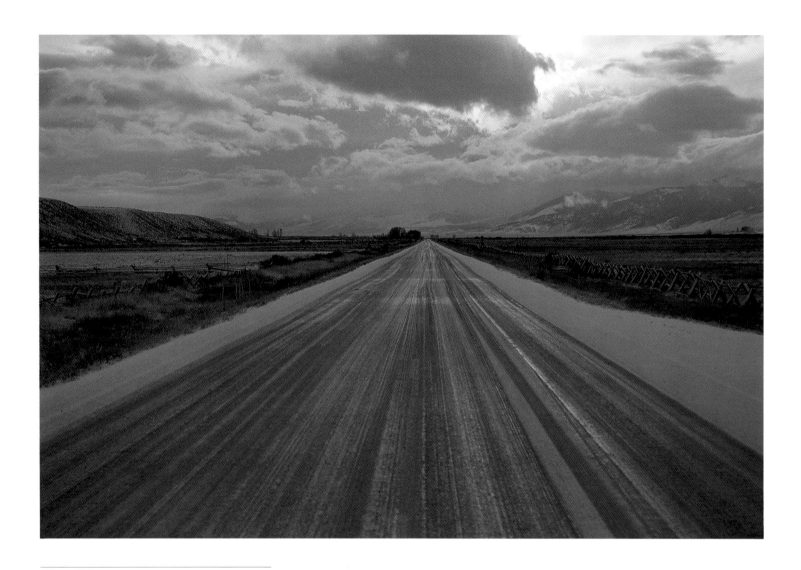

Ice-covered Highway 28 south of Salmon,
November 1991. My car radio would only pick
up a Sacramento station giving rush-hour advice
to morning commuters. Listening to their troubles
while having the road to myself in the Idaho
outback made me feel almost smug.

returning home I invariably headed to the library to learn more about what I had experienced on the road. In this inductive fashion I combined on-site observation with reading and reflection to produce materials for an extended meditation on Idaho and the surrounding West. Over the years I have grown so fond of the hands-on approach that I would now gladly describe myself as a field historian—one who pursues his craft with equal facility and enthusiasm in libraries and archives or while tramping across the land with camera and notebook in hand.

The first published fruit of this peculiar method of study is *So Incredibly Idaho!*, which seeks to combine words and photographs to form what is essentially an appreciative essay–'appreciative' because I call Idaho home, yet I am not blind to blunders that we Idahoans have made over the years. The approach is highly personal (the words and photographs are mostly mine), but by this combination I hope to provoke and prod readers into doing their own thinking about Idaho and its fascinating landscapes. My desire is that everyone will experience the Gem State in a new way.

I have classified Idaho landscapes into seven types that define the state, but if after reading this book you believe the number should be closer to eight or nine, or perhaps only five or six, so be it. Grady Clay in his 1994 book *Real Places* identifies dozens of generic landscapes, places like courthouse squares, parade routes, greenbelts, and even porno districts. At least my seven choices have in common that they are all grounded in Idaho history. There is nothing to keep a careful observer from identifying any number of landscapes that define the Gem State. The total number of them is really unimportant.

Making and defending personal choices makes reading any landscape intriguing, especially when there are no commonly accepted rules of interpretation. Some readers may feel that I should have classified Idaho landscapes into the panhandle, Snake River plain, and other traditional geographical divisions. Frankly, I deliberately avoided these familiar categories because the old sectional approach has caused Idahoans too much trouble over the years. I want us to see ourselves instead as Idahoans all, sharing a common set of defining landscapes.

If in this way I inspire readers to think more about Idaho, to travel its engag-

ing highways, read more about its past and present, and even to refine a sense of place, then I have achieved the modest goal set out for *So Incredibly Idaho!* To make the challenge reasonable I have included a list of suggestions for further reading. In addition, I took most of the photographs within twenty-five feet of viewpoints accessible to the average automobile. These are Idaho landscapes that can be visited and enjoyed by virtually everyone regardless of income level or physical condition.

I am not a professional geographer. Landscape interpretation has long been central to the work of cultural and historical geographers, but my approach is that of a historian who has learned to sponge up useful bits of material from geography and other disciplines. Neither am I a professional photographer, although I always travel across Idaho with one or two cameras close at hand. Any emergency stop would send tripod, cameras, and lenses flying about my car in chaotic fashion. This is one reason why I prefer to enjoy the countryside while dawdling along one of Idaho's many "blue highways."

Being more of a romantic than a technophile when it comes to photography, I tend not to record exposure data. I can say only that I used mainly my Nikon 8008 or F4s cameras. Larger format cameras might have yielded detailed pictures more suitable for calendars, but that was not my intent here. Unless noted otherwise in the citations, I take full responsibility for every word, illustration, human idiosyncrasy, and odd opinion on the pages that follow.

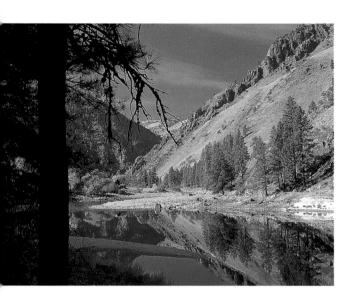

Fall colors and stands of ponderosa pine in the Salmon River valley east of Riggins, October 1994.

Because my approach is unabashedly personal, I want to speak candidly of my own roots. I am an Idahoan by conviction, not birth. Perhaps for that reason, during my years in Idaho I have become increasingly fascinated by what it means to put down roots in a place and how a sense of place relates to landscapes. My own sense of place draws heavily upon experiences gained before moving to Idaho in 1984, although the concept itself became meaningful to me only after I pondered seriously what becoming an Idahoan meant. For people born here such a question must seem silly, but becoming an Idahoan was for me a conscious

choice and not the result of fate (or my parents' choice).

They (and the alternatives forced on them by World War II and its aftermath) were why I was born in Wilmington, North Carolina, and raised in Greenfield, Indiana. As it turned out, those two places were pretty good choices. Greenfield was a pleasant town that even in the 1950s retained some of the bucolic characteristics described by hometown poet James Whitcomb Riley more than half a century earlier. I never met anyone like his "Raggedy Man," but an occasional tattered hobo wandered along the railroad tracks behind our home. Riley's "Old Swimmin'-Hole" was nothing more than a shady recess in nearby Brandywine Creek, and I recall trying its quiescent waters only once. Between the Hoosier poet's time and mine someone had built a slaughterhouse upstream.

I've been partial to small towns ever since Greenfield. My own bookshelves reveal a fondness for the likes of Thornton Wilder's *Our Town* and Garrison Keillor's *Lake Wobegon Days*, not to mention volumes that probe the darker side of small-town life, like Edgar Lee Masters' *Spoon River Anthology*. A kindly photographer I came to know by stopping by his studio often after school gave me my first real camera. It was a large wooden view camera that I soon traded for a more manageable twin-lens reflex. Only years later did my parents reveal the whole story: like a character from *Spoon River Anthology* or *Winesburg, Ohio*, my patron had taken up photography and exiled himself to a small town in Indiana only after being expelled from medical school in Scotland because of a botched abortion.

Wilmington was considerably larger than Greenfield. In the early twentieth century it was the largest city in North Carolina; during World War II it was probably the busiest. Not only was it a major Atlantic port, but when Marines from Camp Lejune and soldiers from Fort Bragg came to Wilmington to let off a little steam, it was my grandfather's unenviable job as chief of police to keep the peace. No wonder his health failed shortly after the war ended. I was too young to know any of this, but I fondly recall my grandparents' modest home on Dock Street, some sixteen blocks up from the Cape Fear River and the waterfront ac-

An example of self-deprecating humor? DON'T BE A GUBERIF is Idaho's wry reminder to motorists not to be firebugs. I found this admonition freshly painted on Idaho 28 in July 1992.

This was one of my earliest (and most blatant) attempts to treat work life as art: the setting sun silhouettes a tugboat mate on North Carolina's Cape Fear River in the mid-1960s. When I recently found this long-forgotten image in a box of my earliest negatives, I was struck by the persistence of youthful interests: two of my most recent books dealt with historic images of work life and transportation.

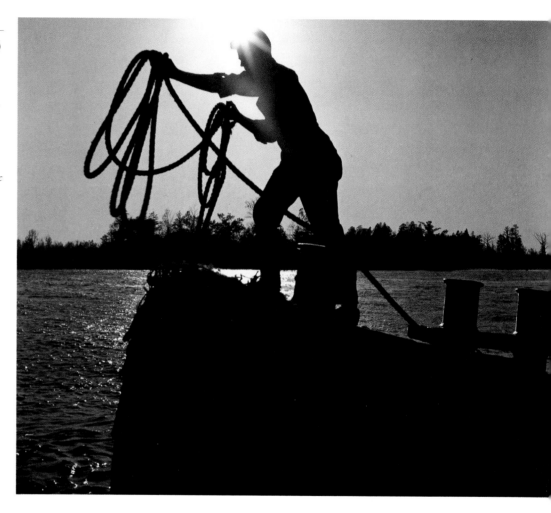

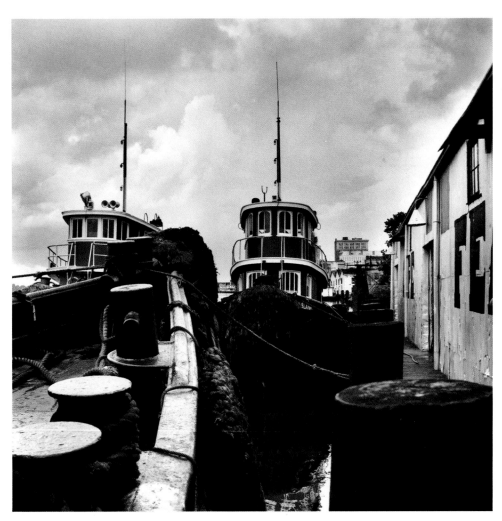

Wilmington's working waterfront in the mid-1960s was a favorite haunt where I honed my love of photography. Beneath wharves that on a sultry summer afternoon reeked of fuel oil and creosote flowed the dark, tannin-stained waters of the Cape Fear River. It is fortunate that this image survived to remind me how in recent years developers ruined the real riverfront by turning gritty warehouses into cloying tourist boutiques.

tivity that gave the street its name. Even on a humid July afternoon it was an easy walk down to the docks where an indulgent tugboat captain might offer me a ride. I recorded the sometimes harsh reality of work life on the wharves on black and white film with my twin-lens reflex camera.

Like the tidewater South in general, Wilmington was shaped by a complex and sometimes disturbing past that came alive for me when I heard relatives recount tales rooted in my mother's family history. When none of the adults were around, old Uncle Zeb V. Hodges (as in Zebulon Vance, North Carolina's Confederate governor) told in a raspy whisper about the bloody race riot he had witnessed in Wilmington in the 1890s. In my child's mind I assumed this was something not to be discussed in polite company, but Uncle Zeb wanted me to know.

In even earlier times, my great-great-grandfather, John Casteen, had been an ardent defender of the South, enlisting in the first regiment of North Carolina State Troops and serving from June 1861 until taken prisoner at Spotsylvania Court House, Virginia, in May 1864. In a way I'm glad I learned this bit of family history only very recently and not as a teenager. It might have further complicated life for a youngster schooled entirely in the North but alternately fascinated and troubled by Southern folkways. Once during the civil rights movement of the 1960s my otherwise indulgent grandmother sternly warned me never again to raise questions of race in a church discussion.

My obliging parents permitted me to spend my first eighteen summers in Wilmington with my grandparents Casteen. A life divided that way, between North and South, probably heightened my interest in state and regional distinctions and later produced great curiosity about a sense of place. At Broad Ripple High School in Indianapolis I wrote a senior essay comparing governors Terry Sanford of North Carolina and Ross Barnett of Mississippi on matters of race and civil rights. This was not a very subtle thing to compare in 1963 (moderate Sanford, intransigent Barnett); the paper nonetheless won an Eli Lilly Scholarship that helped pay for my first two years of college. I still wonder what would have happened had I used the tuition money to go south to study history instead of north to Michigan, or how different my outlook would have been had I spent some of those early summers in São Lourenço, Brazil, with my grandparents

Schwantes, instead of in tidewater North Carolina. Such unanswerable questions bring me back to where I began: never underestimate the fortuity factor.

Since 1984 I have been at the University of Idaho where I teach the history of Idaho and the Pacific Northwest. Earlier I was at Walla Walla College, where I began my teaching career in 1969 fresh from the University of Michigan in Ann Arbor and a doctoral program in American history. Recently, during the Spring 1994 semester, I offered a class called Comparative American Regionalism, which consisted of weekly interchanges with thirteen lively and intelligent graduate students. This agreeable experienced inspired me to move *So Incredibly Idaho!* to the top of the stack of book projects.

My first ten years at the University of Idaho happily coincided with Tom Bell's decade as provost. His support was basic to anything I accomplished. Bell grew up in Inkom (near Pocatello), and though he was much too busy to indulge in extended conversations with me about his roots, I always sensed a genuine pride in his Idaho heritage. His suggestions led me to the engaging agricultural landscape surrounding the near-ghost town of Chesterfield and to the equally fascinating Arbon Valley west of Pocatello. Both places impressed me with the need to know the whole of Idaho, not just the familiar panhandle section where I now live. After a busy year in retirement Dr. Bell returned to serve the University of Idaho in 1995 as interim president.

During her six years as president of the University of Idaho, Elisabeth Zinser was an unflagging supporter of my research, writing, and teaching. I always admired and appreciated the way she immersed herself in the history of her adopted state, and I'm certain she will continue that commendable pursuit as chancellor of the University of Kentucky. Her enthusiasm was contagious. At various crucial junctures, a kind word or a note of appreciation from her provided me the needed psychological boost to finish a project. It is with heartfelt thanks that I co-dedicate *So Incredibly Idaho!* to Dr. Zinser.

For their continued encouragement I am also indebted to former University

A neighborly array of mailboxes in the Arbon Valley, October 1994.

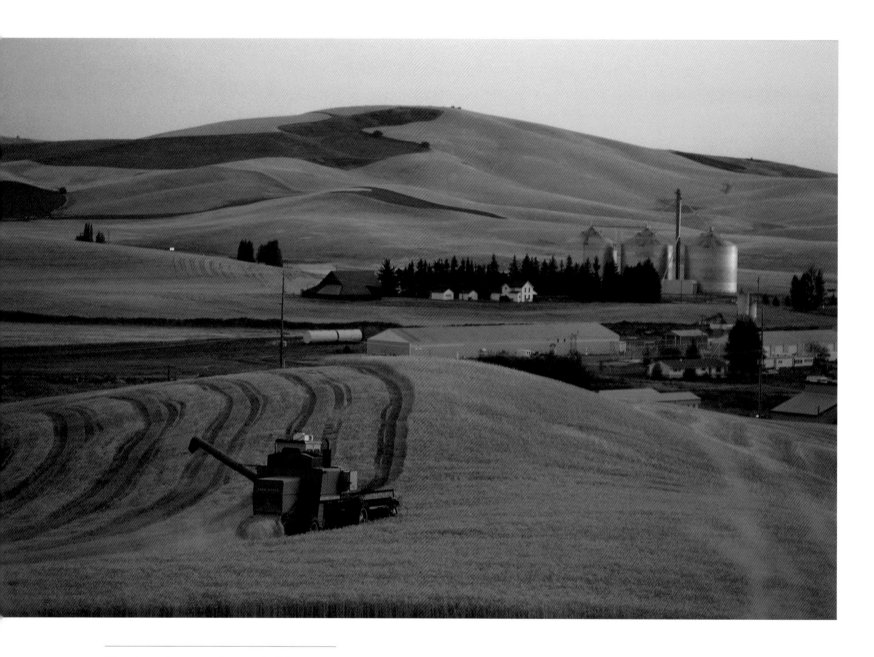

Home base: this sunset photograph of the grain harvest south of Moscow, August 1986, was taken with a telephoto lens from my front yard.

of Idaho Provost John Yost, Dean Kurt O. Olsson, and History Chair Richard Spence. Director Peggy Pace and her skillful associates at the University of Idaho Press deserve full credit for turning my rough ideas into *So Incredibly Idaho!* Book designer Caroline Hagen did a beautiful job of turning my free-floating ideas into reality. Steve Brunsfeld, a professor specializing in Rocky Mountain botany and my valued colleague for several excursions along the trail of Lewis and Clark, helped me identify Idaho vegetation in the photographs.

Off campus my valued sources of insight include Merle Wells, former Idaho state historian; Robert Spude, historian of the National Park Service in Denver and Santa Fe; Rocky Barker of the *Idaho Falls Post Register*; Howard Jones, a rancher near Moscow; and Ralph Lee Hopkins, a talented landscape photographer based in Seattle and northern New Mexico.

INTRODUCTION

SCENIC POTATOES OR SPECULATING ALOUD AND OTHER PERSONAL VICES

SAY THE NAME TEXAS and people typically envision the Alamo or oil wells or longhorn cattle. Say Utah and the words Mormon and snowskiing come to mind; for Montana it is usually big sky and cowboys. For New Jersey I invariably envision gritty cities and heavy industry that, as one writer aptly described it, cause the night landscape to glow like the inside of an old vacuum tube radio. We may debate any list of one or two word images popularly associated with a state's name, but even if the Garden State does contain natural landscapes like the Pine Barrens and centers of refinement like Princeton University, it still has an image problem. So too does Idaho.

Say the name Idaho and many people—Idahoans included—cannot summon a single defining image. Some of us may recall special outdoors places or experiences, like whitewater rafting down the River of No Return or canoeing through twilight reflections of the majestic Sawtooth Mountains across Redfish Lake. Or perhaps nothing comes to mind.

There is, of course, a one word association that Idaho has been spectacularly successful in promoting. That word is 'potato.' But other than thinking of Idaho as

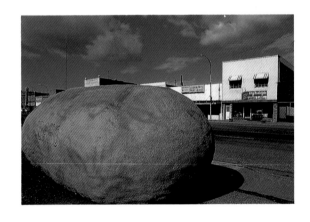

A potato-scape in downtown Blackfoot, September 1991.

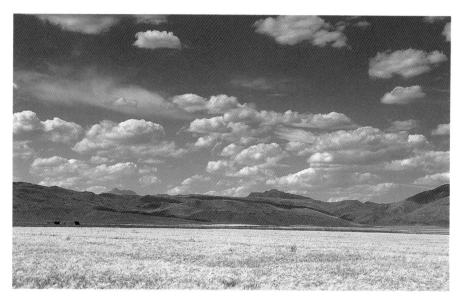

One of the amber fields of grain west of Arco, August 1994.

Seemingly endless fields of potatoes east of Rexburg, July 1992.

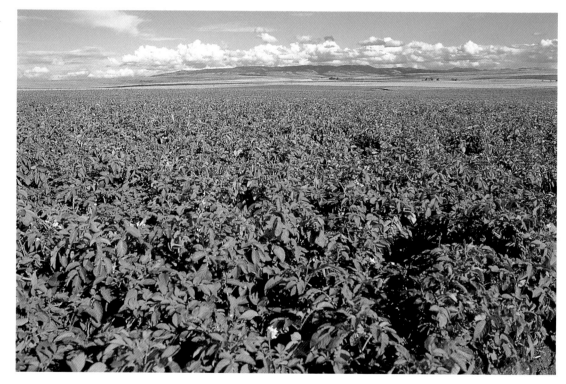

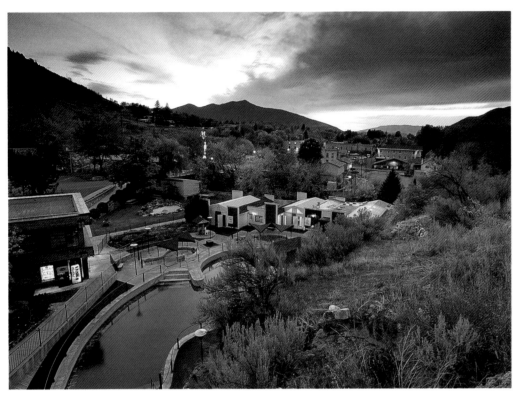

After sunset at Lava Hot Springs, October 1994. One summer evening while relaxing in the warm waters of the pool below, I chatted with a family from California. The parents were obviously well-educated people from the Silicon Valley who wanted their children to experience the natural wonders of Yellowstone Park. We dwelled mainly on the innocuous topics travelers tend to talk about in such circumstances: where are you headed? what have you seen? But when I suggested a scenic alternative for their return trip that included the Sawtooth Mountains, they only responded with blank stares. They had never heard of them. Even wandering off U.S. Highway 30 into Lava Hot Springs had been only an unintentional act. Idaho, it was clear, was but a name they gave to a large blank space on the map.

endless fields of famous potatoes, many people still have trouble envisioning any landscape that defines the Gem State. If the truth be known, I suspect a good many onlookers couldn't distinguish a field of famous Idaho potatoes from one of not-so-famous but still valuable sugar beets.

For some Americans even correctly placing Idaho on a mental map of the United States poses a serious challenge. I once stopped for fuel at a service station in a western Pennsylvania town. The attendant, a middle-age gentleman, observed to me as he pumped gas, "Say, I love your famous potatoes, but tell me is Idaho located east or west of the Mississippi River?" I felt like responding that Idaho was not a real state at all, only an advertising gimmick created by the food industry to sell potatoes.

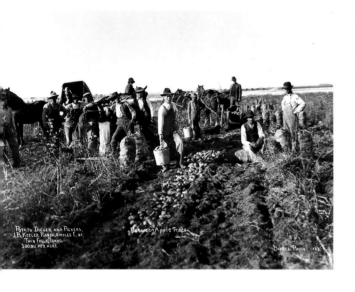

Clarence Bisbee photographed potato diggers and pickers in the Twin Falls area in the early twentieth century. Courtesy: Utah State University Special Collections and Archives, A-3463.

If it is hard to clarify Idaho geography for Easterners, it is nearly impossible to convince them that we don't raise many famous potatoes in the northern panhandle. In fact we often cannot buy the best quality Idaho potatoes: those sold by supermarkets come mainly from Washington or North Dakota. Service clubs up here do sometimes truck in sacks of quality Idaho spuds for fund raisers. But apart from potatoes, the Idaho landscape remains a void or great unknown: Once I was at Mammoth Hot Springs in Yellowstone Park (the most unknown portion of which appropriately extends into Idaho) when two men with New York accents began speculating about geologic changes the terraces had undergone during the past century. Suddenly, one turned to the other and exclaimed, "Say, do you suppose the eruption of Mount St. Helens affected underground water here?" After a moment's reflection the other responded, "Well, I'm sure it must have. Mount St. Helens is just across the mountains in Washington State."

What happened to Idaho? I recalled seeing a map depicting a New Yorker's view of America in which New York City appears to extend halfway across the continent. Everything west of the Hudson River is condensed. Idaho is missing, and so too is much of the Pacific Northwest apart from Mt. Saint Helens and Seattle. The foreshortened perspective is supposed to offer a humorous look at the way New Yorkers see America, but Idahoans know the truth behind the humor. We're convinced a similar map could be drawn to represent the perspective from anywhere on the East Coast.

During a vacation visit with my North Carolina relatives I purchased a few snack items for a Wrightsville Beach picnic. To cash a traveler's check I had to show the clerk my driver's license. A simple gesture, you'd think, but on various occasions in the multicultural Southwest it has elicited a skeptical, "You don't look like a Carlos," and after the North Carolinean clerk briefly pondered my photo and address she observed, "Y'all are shore a long way from home. It's really nice to have you folks down here from Ohio." I responded politely, "We're actually a longer way from home. We're from Idaho." But when returning my change, she still bid a cheery, "Y'all have a nice trip back to Ohio." There was nothing more I could say. I might just as well have tried to explain to an Arizonan what a real Carlos looks like.

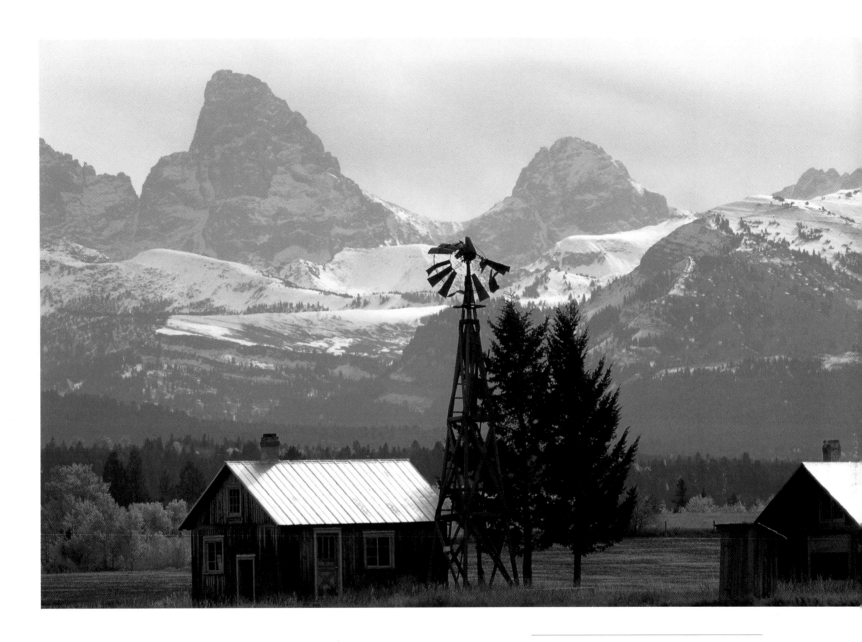

Idaho or Wyoming? No wonder people have trouble forming a defining image of Idaho. The Grand Tetons of Wyoming provide a breathtaking backdrop for this Idaho farm landscape north of Tetonia, October 1994.

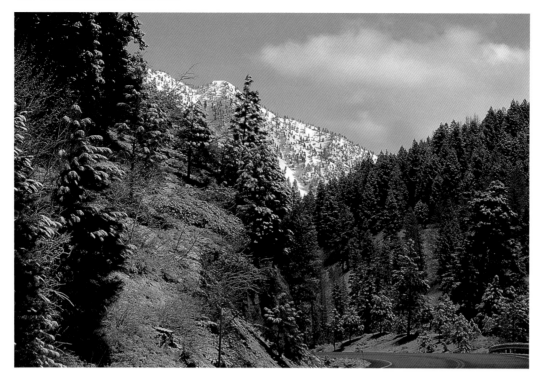

Highway 21, winding its way through a thick forest of Douglas fir and ponderosa pine, is nearly lost in mountain grandeur north of Lowman, April 1995. Fundamental to any understanding of Idaho character is recognizing that much of the state remains uninhabited or only lightly populated. Defined by several dozen major mountain ranges, forests that cover forty percent of the state's area, and seemingly limitless expanses of rangeland, Idaho during the last third of the twentieth century still retains many frontier characteristics. Even in the 1990s, counties with fewer than two persons per square mile, the traditional measure of the American frontier, still accounted for forty-four percent of the state's land area.

Like most Idahoans I have learned to respond to frequent misidentification with Ohio and Iowa with resignation and a sense of humor. Stories of geographical confusion are now a staple of our state's folklore. We exchange new ones at social gatherings and print collections of them in books. They all underscore our conviction that Idaho is little known and much misunderstood.

Perhaps our next generation of automobile license plates should read "Idaho: The Great Unknown." After all, there is something both mysterious and compelling about the unknown. It has motivated explorers from Marco Polo to the Challenger Seven, and an unknown landscape appeals to tourists who avoid beaten paths in their quest to discover new and exotic places. At least it might cause people to ask a few questions about Idaho, which is better than being ignored completely, as happens too often when our license plates cater only to taters. However, many Idahoans relish the solitude that comes from remaining unknown: their attitude is, don't discover us until we choose to discover you.

Our current plates, reflecting Idahoans' usual deep-seated differences of opinion, do have legends promoting both "Famous Potatoes" and "Scenic Idaho." So if "The Great Unknown" does not appeal to you, we could save money (a consideration always uppermost in the Gem State) and still spur curiosity in outsiders by using the slogan "Scenic Potatoes."

THE GREAT UNKNOWN

Idaho's complex geography (and even more complex history) is why Idaho is one of the least known and most puzzling of American states. It is 'the Riddle of the Rockies,' in the words of the *Los Angeles Times*. It is actually a riddle twice over. Not only is the entire state enigmatic to outsiders, but distant parts of the Gem State are perplexing even to Idahoans.

It is not hard to understand why these perceptual problems exist. First, there aren't many Idahoans. The entire state of Idaho in 1990 had a population equal only to that of the city of San Diego, or just over a million people. Our population is less than one thirtieth that of California, our high-profile near-neighbor to the south. But giving the million residents of the Gem State plenty of elbow room is the fact that our state extends across an area the size of the six New England states plus New Jersey, Maryland, and Delaware combined. Or to imagine the area another way, Idaho covers almost as much of the globe as the United Kingdom of Great Britain and Northern Ireland.

Idaho is not just large and sparsely populated, it is sprawling, a defining quality to be measured more in terms of human psychology than in miles. Its area is not as large as it was in 1863 when it covered even more ground than Texas does today. There are twelve states larger than Idaho; but even in this age of high-speed automobiles and electronic information highways, Idaho still ranges across the landscape in an ungainly manner. Physically it is a long way from Bonners Ferry and Coeur d'Alene in the north to Pocatello and Montpelier in the southeast. By road it is almost as far as from New York City to Chicago (about 790 miles); culturally and psychologically it may be even farther.

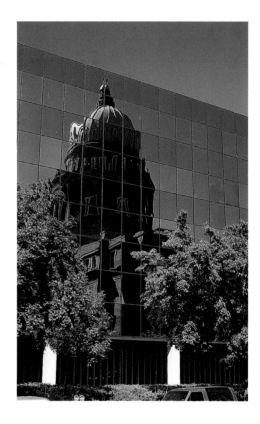

Reflection of the state capitol, Boise, July 1986. A popular quip in geographically fractured Idaho is that the state has three capitols: Spokane for the northern half, Salt Lake City for the southern half, and Boise for everywhere else.

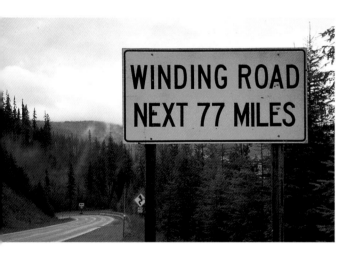

West of Lolo Pass a sign warns of the many curves ahead on U.S. Highway 12, September 1992.

So sprawling and *divided* is Idaho that many Idahoans don't have a good understanding of their own state as a whole. North and south, we are often at best distant and none too solicitous neighbors. We live in separate states of solitude.

The resulting sectionalism takes many bizarre forms. Too many people living in the panhandle, for example, passionately believe that Idaho's natural beauty is confined mainly to the north, a region with a stunning juxtaposition of lakes, mountains, and forests. But as I hope to illustrate, nature liberally endowed all parts of the state with strikingly beautiful vistas that cause romantics like me to exclaim aloud, "so incredibly Idaho!" More practical observers like Sergeant Patrick Gass of the Lewis and Clark expedition, who faced the daunting prospect of crossing the high country on foot in snow, proclaimed the area a "horrible mountainous desert." Two hundred years later the diverse landscapes of Idaho, and the desert vistas most intensely, continue to evoke expressions of awe or distaste that contribute to state sectionalism.

Personally, I believe Idaho still has too much sectionalism. This is the result, no doubt, not only of our geographic variety but also of our state's wholly arbitrary manner of creation: Congress drew lines on a map of the United States without any reference to the limitations imposed by mountain ranges, non-navigable rivers, and waterless plains that made travel and communication difficult if not impossible. Boundaries and spatial relationships that defied both common sense and history forced early Idaho to wage a fierce struggle for survival that too often pitted one section or people against another in a fight over scarce resources.

This became habit-forming. At times it seemed the only thing that all of the sections of Idaho Territory had in common was that they had nothing in common. The residents of one section feared or actively disliked the people living in other sections. In short, early Idahoans occupied very little common ground, nor did they desire to. The social fabric was weak and full of holes, reflecting divisions between native and non-native peoples, Mormons and non-Mormons, Asians and non-Asians, capital and labor, city and country.

Nor did most early Idahoans desire anything more than the most minimal forms of government. Many of them fled to remote Idaho to escape the officially

Sunlight filters through the DeVoto Cedar Grove,
a popular stop along U.S. Highway 12, August
1992.

sanctioned harassment of individuals for their beliefs. This was true of Mormons fleeing persecution no less than of supporters of Union or Rebel causes during the Civil War, who desperately sought to escape a bloody and terrifying guerrilla conflict in Missouri that nearly tore that state apart. In some cases, though, partisans only transferred their Civil War battles to the barrooms and saloons of Idaho's early mining camps.

The marvel was that Idaho still existed in 1890, the year of statehood, after enduring twenty-seven exceedingly troubled years as a territory. If those early years could be compared to the birth, infancy, and adolescence of human growth, then poor Idaho Territory endured the trauma of a difficult birth followed by paternal neglect, all made worse when at least two distinct personalities were arbitrarily confined within a single body politic. In humans the condition is called schizophrenia; in Idaho politics it is labeled sectionalism.

Fighting for survival in the midst of the Civil War, the national government had little money to spare for the care and feeding of its new arrival, which, incidentally, then included not just present-day Idaho but also all of Montana and most of Wyoming. To make matters worse, a well-meaning but often distracted Uncle Sam inflicted poorly qualified (and sometimes incompetent or openly larcenous) governors on the struggling territory.

But young Idaho was a survivor. The amazing thing is that along the way, Idahoans did a remarkably good job of overcoming the deepest personal animosities and divisions. For more than a century, Idahoans have learned to live with sectionalism, to curse it, to joke about it, and somehow to surmount it. Not without reason could Idaho celebrate as its unofficial motto, "Divided We Stand."

I must sound a note of caution here. It is easy to emphasize historic divisions and differences and thereby miss the common ground that Idahoans have come to occupy today. Idaho's immense and rugged backcountry affords the same recreational opportunities to residents living in places as diverse as Lewiston and Boise. Idaho's north and south have also shared a common natural-resource based economy for well over a century. The Gem State as a whole remains fundamentally rural, ranking among the most rural of the fifty states today. North

or south, easy access to the outdoors contributes to the state's generally informal lifestyle.

Some forms of state sectionalism persist nonetheless, and over the years the various troubles and tensions of early Idaho appear to have transmuted into a pronounced and feisty form of individualism. There is an attitude of, "I've got my personal Idaho, now leave me alone and keep my taxes low and regulations minimal."

Shortly after I moved to the state in 1984, an older and wiser colleague urged me to adapt to Idaho's basically relaxed yet conservative approach to life. Anyone who pushed too hard for change, he warned, would probably meet with one of three time-honored refrains: it will cost too much, it has never been done before, and don't you know this is Idaho! I mistakenly thought that this was an example of typical self-deprecating Idaho humor until I came to realize how true it was.

The amazing thing is that Idahoans have figured out how to mix fiscal conservatism, celebration of personal freedom, and accommodation to vast open spaces to produce not only a good life for themselves but also a political culture that is basically tolerant of individual differences. Despite the media stereotype of the Gem State as a haven for bigots, it is worth noting that Idaho was the first state to elect a Jewish governor (Moses Alexander) and a Native American attorney general (Larry EchoHawk).

It is outsiders looking in who can't seem to get the mix right. From the vantage point of southern California or some other densely populated area, a person may be tempted to view open spaces and low population density as an invitation to return to a mythical frontier simplicity they imagine lingers on in Idaho. Or because of Idaho's small non-white population they imagine a lily-white sanctuary free from the challenges of a modern multiracial society. It is easy to forget that Idaho's population was once one-quarter Chinese. Often the national news media dramatizes the activities of the California expatriate Richard Butler who at Hayden Lake founded the neo-Nazi Aryan Nations and built a fortress compound complete with school, guard post, and living quarters, but it will ignore everything else about Idaho. In fact, less than ten miles from Butler's compound

Modern frontier: a mixed coniferous forest composed of Douglas fir, ponderosa pine, white pine, and other species lines the Lochsa River and U.S. Highway 12, October 1994.

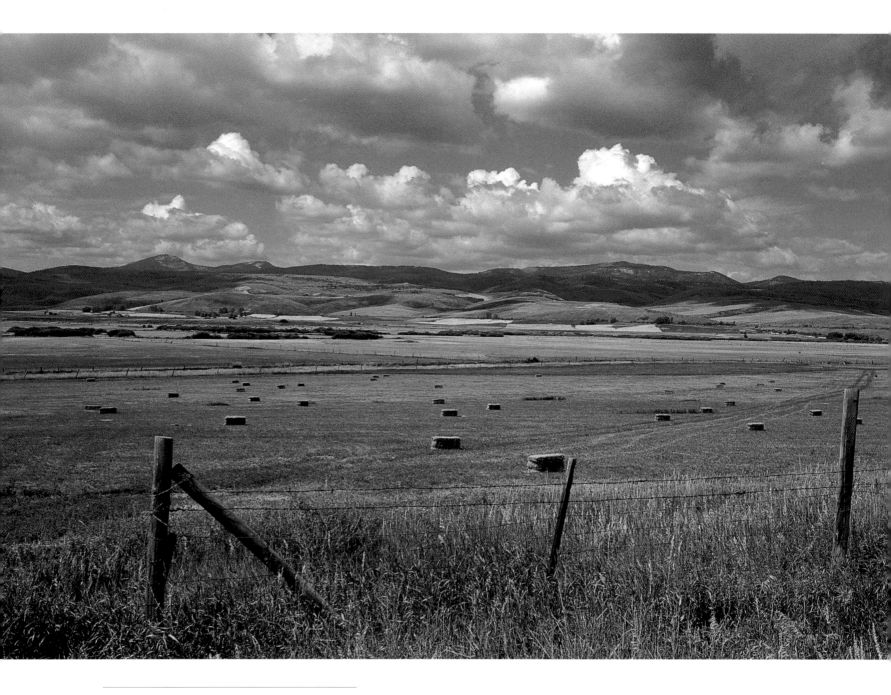

*An agricultural landscape west of Ovid on Highway
36, August 1994.*

is Coeur d'Alene, rapidly gaining population and fast becoming a world-class re-sort, and farther north is the trendsetter community of Sandpoint, which in re-cent years held an annual music festival that attracted nationally recognized artists.

Because the Gem State is so little known or only poorly understood by so many people living outside Idaho, when a few fringe individuals or groups at-tempt to live out their private fantasies here, it is easy for distant observers to form misleading opinions of Idaho in general and to believe all the worst things the national news media is capable of saying. As a result, the Gem State may ac-tually appear frightening to people who have not seen it up close. That's the downside to Idaho as the great unknown.

No question about it, Idaho remains vulnerable no matter how it is perceived. It remains vulnerable to media misrepresentation no less than to economic events occurring thousands of miles away, events which affect the prices of basic commodities crucial to the financial health of the Gem State. It remains vulner-able to water woes in southern California and to numerous other forms of California malaise that have the potential to send new residents cascading north in search of heaven in Idaho. But vulnerability, as the historical record shows, is nothing new to the Gem State.

EXPERIENCING IDAHO LANDSCAPES

The study of Idaho landscapes has the power to dispel myths that make it difficult for people to envision what the Gem State is really like. It can amplify under-standing of how today's Idaho is a product of its complicated past. But readers may still wonder why anyone should attempt to read our state's landscapes when numerous volumes of Idaho history are already easily available in every school and public library. What do landscapes say that any good history book doesn't? We are surrounded by landscapes, every one of which is capable of making a statement about past and present, about individual and community preferences and values, even about fears and aspirations that can persist across generations.

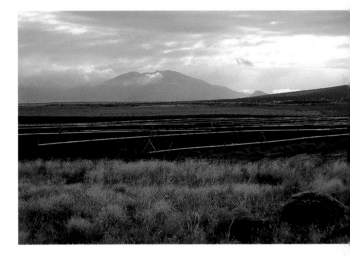

First light reflects off irrigation pipes north of Pocatello, September 1992.

No matter how self-serving individuals may be when it comes to recording their daily lives in diaries and journals, landscapes reveal the truth. Landscapes give voice to the inarticulate.

Landscape study provides personal insight that books alone can't. As much as we might wish it, we cannot travel back in time; but through visiting landscapes we can go back to experience a place, and in an odd sort of way make emotional connections between ourselves and the past. I'll never forget the personal thrill that came from driving up to Lemhi Pass, the high mountain border between Idaho and Montana, where just a few yards east of the continental divide I was able to straddle the supposed source of the Missouri River, doing exactly what men of the Lewis and Clark expedition had done on August 12, 1805.

Private Hugh McNeal, a Pennsylvanian, planted his feet triumphantly astride the tiny spring he believed to be the headwaters of the great river that had been his lifeline and constant companion for more than a year. In Lewis's words, "McNeal had exultingly stood with a foot on each side of this little rivulet and thanked his god that he had lived to bestride the mighty & heretofore deemed endless Missouri." If there is in reality a better time machine than remote Lemhi Pass, or any other landscape of great historical significance, I'd like to climb aboard.

Gem State landscapes (and even those now in Montana) should be viewed as complements to books and articles. They should be read in conjunction with the printed word, not to its exclusion. To those who care to read them, the defining landscapes of contemporary Idaho are themselves chapters of an open book, revealing key aspects of the state's heritage. Even if we do not understand fully all we observe, a closer look is still a useful way to peel back the layers of Idaho history. Changing patterns of transportation, abandonment of little-used railway lines and construction of a network of interstate superhighways, can easily be traced in landscapes across the state and used to visualize the forces that have done most to shape Idaho's recent past. Landscape study can stimulate interest in Idaho's Native American heritage as well as in its early Euro-American exploration and settlement. Ruts remaining from the Oregon Trail speak volumes about the past.

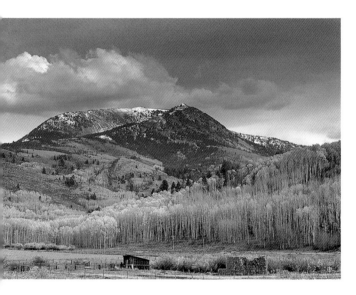

Fall colors north of Wayan, October 1994.

Admittedly some aspects of Idaho's past do not appear to lend themselves to this kind of hands-on history: the study of political trends and leadership seems to require a more traditional approach. Yet decisions made in councils and legislative chambers will also reshape the landscape. How, for instance, can we separate wilderness lands from the emotional political debates they often generate?

Every reader is probably acquainted with at least some portion of Idaho's vast and varied landscape. Experiencing the landscape that surrounds us must be among the most universal of human needs, ranking somewhere with food and sex, yet few people think seriously about it until they've experienced a landscape that is either highly exhilarating or utterly depressing. Which emotional response it may trigger is a matter both of individual taste and cultural conditioning.

Perhaps it is time to discuss what a landscape actually is. My working definition, but certainly not the only one possible, is that a landscape is the outdoors space that can be observed and *experienced* from one particular vantage point. In a moment I'll explain why I emphasize the word experienced, even though most of us initially tend to think of landscapes only in terms of what we can view, such as when we scan a mountain panorama. Landscapes can be further classified into two broad categories, both of which are always in evolution; it is as difficult to imagine a purely static landscape as it is to envision an attractive clear-cut in an old-growth forest.

The first category of landscapes is that of natural landscape unaltered by human intervention. Despite our many mountain ranges and unpopulated spaces, pristine natural landscapes are a rarity even in Idaho. Once on a flight over the great outback from Boise to Lewiston, the passenger next to me observed that it was overwhelming to look down upon so much land that humans had never touched. Actually, what he regarded as a natural landscape had been explored in intimate detail by fur traders, and the later impact of miners could still be seen in many places upon close examination. Native American trails and campsites were discernible if one knew where to look.

Even seemingly natural landscapes reveal as much about our cultural conditioning as about nature. An observer must ponder why, for example, we pre-

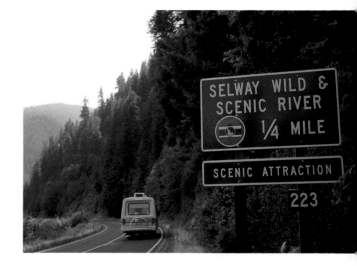

Along U.S. Highway 12 east of Lowell, motorists find a sign for the wild and scenic Selway River, August 1994.

serve some landscapes as natural and not others. Why do we consider some of them visually arresting but others merely boring? Why do old-growth forests become spiritual groves for some people and only sources of timber for others? Attitudes, moreover, do change dramatically over time: two centuries ago alpine scenery was so disturbing to European travelers that they rode along mountainous roads in coaches with the curtains drawn shut.

The second broad category of landscapes is made up of cultural landscapes. These include common or vernacular landscapes, which are basically unselfconscious creations, the by-products of laws, building codes, religious beliefs, personal opportunity, economics, or any combination of these. There are also cultural landscapes that are consciously contrived to be functional (as in former company towns like Potlatch), to be aesthetic (as in formal gardens or campuses like the University of Idaho), to make money (true of any shopping mall), or to evoke a nonexistent or lost past (like Sun Valley with its hint of the Austrian Alps). Finally, cultural landscapes include those that people consciously save from destruction, as happens when they gentrify vernacular landscapes, preserve historic structures and neighborhoods, or set aside park landscapes to maintain old fortifications, battlefields, or ghost towns.

As I emphasized earlier, a landscape is much more than a visual or object-oriented experience. Observation may be the one aspect of landscape study that lends itself best to photographs and others forms of illustration, but ideally a landscape is more than a vista that can be reduced to a picture postcard and other tangible tourist souvenir. A landscape properly experienced should connect with all human senses, not just sight.

For example, consider the Cypress Swamp located north of Jackson, Mississippi, along the Natchez Trace Parkway. A photograph could provide you with the look of the swamp (the visual experience) but not the actual feel of the landscape. I would need a camcorder or tape recorder to capture the sound of countless cicadas hidden but still irritatingly audible in the tree tops. Their rasping tone suggests hot, muggy weather to any Southerner. Even so, I know of no instrument that can record the sensation of one hundred percent humidity or the smell of the swamp (or of Idaho hot springs, which are often equally pungent).

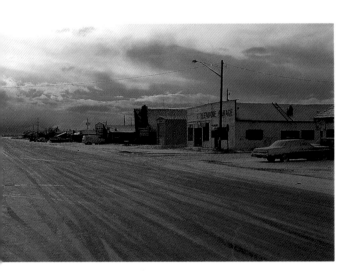

Winter comes early to Leadore, November 1991.

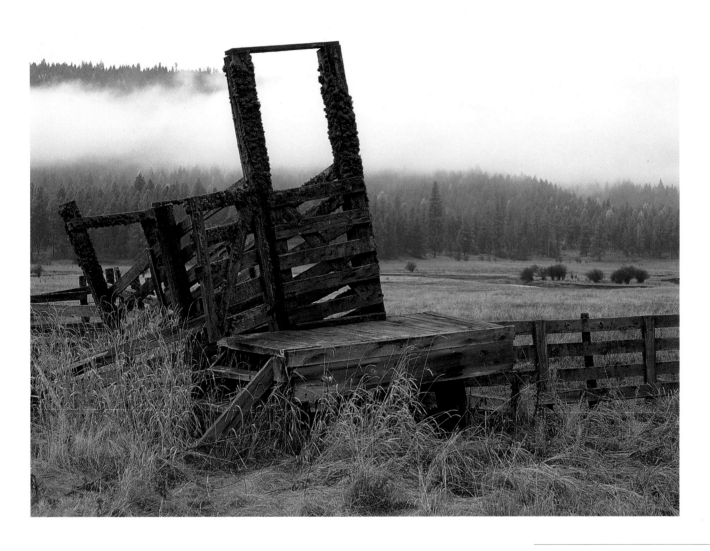

An icon of the Real West: cattle loading chute along U.S. Highway 95 north of New Meadows, November 1991.

Mountains overshadow the town of Whitebird, April 1995.

Likewise, a photograph of Arizona's Sonoran Desert would give the look but not really the feel of an arid landscape, no matter how hard *Arizona Highways* and other lavishly illustrated publications may try. Where is the dry heat, the pain of jumping cholla in your ankle when you've brushed too close, or the sweet aroma of a creosote bush after a thunderous desert rain? Where, too, are the various sounds of the desert after dark, like coyotes baying at the moon?

Or how about a glacier landscape? I could show you pictures of Alaska's stunningly beautiful Glacier Bay, but you need to hear the "white thunder" of a glacier calving or the "snap, crackle, and pop" of floating icebergs to fully experience the place; you need to feel the ship rock as shock waves spread through the water.

As much as I enjoy capturing the North American landscape with my camera (and thousands of color slides offer proof of my obsession), I am increasingly aware of the limitations of still photography to capture the look *and feel* of a landscape. A couple of years ago I purchased a good quality Canon camcorder to help extend the range of experience. Alas, the typical consumer-oriented camcorder simply cannot do the job. A person must be willing to invest a small fortune in a broadcast-quality camera because the colors of landscapes captured on home videotape are far less vibrant than those on 35 millimeter slides, and without supplemental sound equipment the camcorder (even the best consumer model) lacks the audio clarity needed to capture the intimate sounds of a landscape. The best an accomplished still photographer can do is to engage in what I would call *sensory shifting* by including visual clues that *suggest* heat and humidity, wind speed, the smell of dust, and like qualities.

The problem of fully experiencing a landscape intrigues me because the variety of sensory encounters is so often overlooked by interpreters. Most information signs posted along highways and in parks are strictly visual. Of the thousands I've read, only a minority attempt to explain the landscape apart from its appearance. Why, for instance, do cicadas make the sounds they do? Or how about an interpretive sign at the edge of a southern swamp landscape that starts with the words: "Do you feel the moisture in the air? Do you smell the odor of decaying vegetation?" The sign should go from there to heighten visitors' consciousness of the need to *experience* the landscape. In a related way, I want to encourage readers to be more inclusive in making sensory connections between themselves and the landscape, even if this book is itself inescapably a visual study.

How many motorists have ever seen highway signs warning of unpleasant odors ahead, much less attempting to interpret odors of all types that occasionally will drift into an automobile? The challenge is impossibly difficult and my concern may seem silly, for in truth it probably doesn't matter much whether olfactory interpretive signs exist or not: modern air-conditioned and stereo-equipped cars and multi-lane, scenery-crunching super-highways conspire to keep us from experiencing genuine American landscapes along the way. That's why when I drive along country roads I do so with the windows down (where

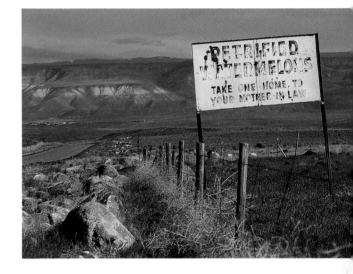

A faded sign along old Highway 30 near King Hill, April 1995. It reads "Petrified Watermelons: Take One Home to Your Mother-In-Law." One more example of Idaho humor, it was once part of a series used to advertise Stinker gas stations.

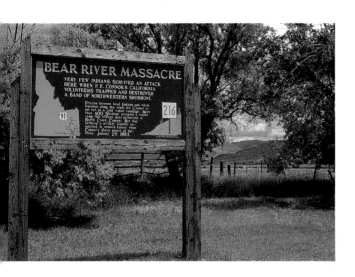

Bear River Massacre sign, July 1992, makes the invisible landscape visible. I've traveled to all fifty states and never found any that surpassed Idaho in public interpretation of its historic landscapes. Those informative signs are the joint product of the Idaho State Historical Society and the Idaho Department of Transportation.

practicable) and the radio off. I want to smell the landscape, listen to it speak, and, yes, be blasted by dry heat during a summer afternoon on the Snake River plain and be revived again by ozone after a thunderstorm.

Perhaps because our climate-controlled automobiles and super-highways have cut us off so effectively from real American landscapes, it is not surprising that contrived ones have become so wildly popular. Visitors can look at a desert environment in Florida's ever-humid Disney World (in the runaway mine train ride) in much the same way they can drive across one, but they never truly experience its impact on any human sense except sight.

There is yet one additional aspect of experiencing the landscapes of Idaho and the West: we need to sense both the visible and the invisible ones. Obviously the visible landscape, being tangible, is much more appealing to most visitors, and certainly it is easier to interpret. The invisible landscape, consisting mainly of important historical events and processes that are no longer discernible by casual visitors, presents a greater problem of interpretation.

I realized this as never before when I was hired to do a week of historical commentary aboard a small cruise ship in Alaska's Inside Passage. Glaciers and bears and eagles had an obvious and immediate appeal for the passengers, especially since this voyage had been promoted as a wilderness-oriented cruise. But how could I overlay the visible natural landscape with the invisible historical one that included Captains Cook and Vancouver, or even the gold rush days of 1898 when the cruise did not include Skagway with its many vivid reminders of Alaska's mining past? My challenge was to make the invisible landscape visible.

It is no less a challenge in Idaho today where the process of bringing historical imagination to the landscapes crossed by Lewis and Clark or the Oregon Trail offers exciting personal possibilities and has in recent years also formed the basis for several profitable tourist ventures. The Smithsonian Institution marketed tours along the Lewis and Clark trail through the Bitterroot Mountains of northern Idaho. Another adventure in history called "In the Wake of Lewis and Clark," offered by Sven-Olof Lindblad's Special Expeditions of New York City, transports modern voyagers by ship along the Snake and Columbia rivers between Lewiston and Astoria, and even slightly beyond that point to the Columbia's ca-

pacious mouth. Special Expeditions contracts with local jet boat operators to take travelers up the Snake River from Lewiston to China Bar in the heart of Hells Canyon.

Having served as historical interpreter on nine of these week-long voyages between Lewiston and the Pacific Ocean, seeking to make the invisible landscape come alive, I am certain that passengers—each having spent more than two thousand dollars for the experience—are transported as much by their own meditations on the past as by luxury ship. But personally experiencing any historical landscape depends far less on money than on individual study and imagination.

PLAYING WITH LANDSCAPE PERCEPTION IS SERIOUS BUSINESS

Certain landscapes preserved within local, state, and national park systems appeal to a visitors' sense of history, while others appeal to a sense of awe, grandeur, and curiosity. But how is it that landscapes stir powerful emotions in people? The fact is, even in the most evocative situations we don't simply experience a landscape; we draw it into ourselves through the filter of culture (which is often a fancy way of describing the impact of movies and advertising on our daily lives).

This elementary principle of landscape study initially became plain to me in 1970 when I was a first-year college teacher in the Walla Walla area in the southeastern corner of the state of Washington. Shortly before the school term ended, a student in one of my American history classes burst into my office and excitedly reported, "Guess what? My family and I are going West for our summer vacation."

Because I had always lived in the East prior to moving to Walla Walla less than a year earlier, I responded with an innocent question: "Are you headed to Portland, Seattle, or San Francisco?" She looked puzzled as she hesitantly replied, "No, we're going West to Laramie!"

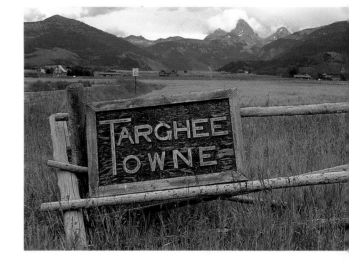

Targhee Towne, a new development in the Teton Valley, July 1992.

Since then I have seen clearly that a person can travel geographically West or psychologically West and not necessary be headed in the same direction. No matter where on the map I begin, I will always travel west to reach former mining centers like Silver City or Idaho City (and even Bodie, California, and Jacksonville, Oregon); but when I head to the urban landscapes of Portland, Seattle, and San Francisco I must go *west of the West*. Geographically they are located in a region called the West, but they're not of it in terms of the aridity, landforms, and various symbols that popularly define the West.

It is all a matter of making the right connections with words and symbols. Movie makers have long known that, and so too advertisers. Take a close look at the label of a popular brand of salsa. On it is the name Old El Paso and the symbol of a saguaro, although the familiar cactus with the upraised arms does not grow naturally within three hundred miles of El Paso, old or new. Yet you could never sell the same powerful image and product with a name like Old Pocatello or Old Kamiah or substitute syringa, the Idaho state flower, for saguaro.

The landscapes of Laramie or Cody or Tombstone have the look and feel of what I have come to label the Real West. Some readers may prefer the designation "Deep West" to avoid any confusion with places on the western periphery, but I like Real West because it contains more than a hint of irony when so many aspects of its landscape are wholly contrived. But as the great P. T. Barnum realized more than a century ago, Americans love to be fooled.

Many tourists come to the Real West burdened with a vast array of preconceived images they wish to validate personally, and if they cannot do so satisfactorily within formally designated public parks, they often continue their quest in the contrived landscapes that smart entrepreneurs have created for tourists outside the most popular national parks and monuments. This is undoubtedly why western theme parks and contrived landscapes are so popular, notably in the Black Hills of South Dakota, a locale richly blessed with natural beauty and the spine-tingling national pride evoked by Mount Rushmore. Yet, in the Black Hills are also located some of the most blighting examples of roadside attractions best described as trash tourism.

Often these contrived landscapes become more real and appealing than the

genuine article. One summer when I was walking with a group of tourists through a portion of Mammoth Cave, I overheard one exasperated mother promise her unruly youngster, "If you'll only behave in here, I'll take you to Guntown Mountain when we're done. That's where they have gunfights in the streets."

In some strange way the Real West has become in the late twentieth century a vast and ongoing theatrical production not unlike that found in theme parks, a case of Disney's Frontierland vastly enlarged. When I visited Natchez, Mississippi, a few summers back I saw no one walking the streets dressed up in the fashions of a Rhett Butler or Scarlett O'Hara. One mansion tour guide did wear a hoop skirt typical of the antebellum South. Neither did I find any Southern wear shops in Natchez—a place which bills itself as "Where the Old South Lives On"—nor in Charleston, South Carolina, or Savannah, Georgia. Nor, come to think of it, did I ever see anyone on the streets of Boston or New Haven or Providence dressed as Cotton Mather or John Winthrop. I've searched New England in vain for Pilgrim wear shops.

But go to Boise, Billings, Sheridan, Tucson, Fort Worth or Denver and it is not uncommon to see men and women strolling the streets in western wear. Few residents of the Real West feel self-conscious when they dress in cowboy boots and hats. As for western wear shops, they're located not only in Idaho and other states of the Real West but also in distant Florida and Georgia. In truth, most such businesses are really only costume shops. A few sell mainly to working cowboys; most don't. A shop owner in Sheridan, Wyoming, told me that visitors living out their western fantasies supplied at least half his annual income.

The landscape of the Real West is not unlike its contrived dress style. Has any landscape been portrayed more vividly or more insistently in the popular media? Only consider the number of motion pictures, television series, and popular novels that depict an idealized western landscape in terms of expansive skies, red-rock canyons, mesas and buttes, purple sage, and the like. Is the landscape iconography of any region of America more instantly recognizable?

Here we come back to the perception problem involving Idaho the great unknown. I once knew a writer who finished a novel about Idaho and then changed

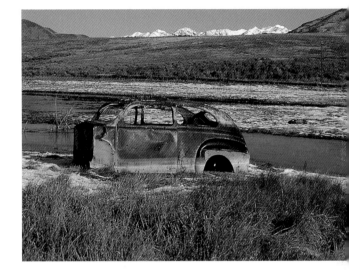

Automobile landscape west of Craters of the Moon, November 1991. Like trash tourism, its appeal lies in the eye of the beholder. Near Amarillo, Texas, is Stanley Marsh's Cadillac Ranch, where a line of the automobile behemoths lies half buried along Interstate 40; in a cornfield near Alliance, Nebraska, stands Carhenge, an astonishing recreating of the original Stonehenge using old cars. In Idaho, automobile landscapes just happen.

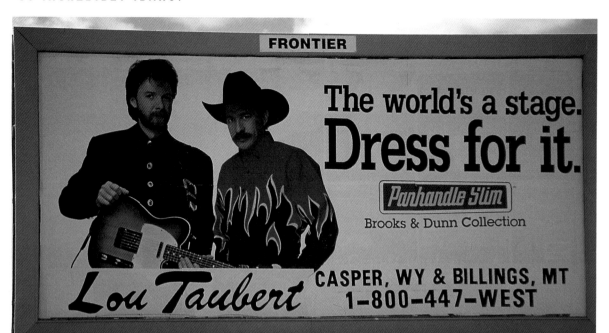

FRONTIER

The world's a stage.
Dress for it.

Panhandle Slim

Brooks & Dunn Collection

Lou Taubert

CASPER, WY & BILLINGS, MT
1-800-447-WEST

I spotted this sign on the outskirts of Gillette, Wyoming, in July 1993. It conveys a powerful message about the connection between western wear and the landscape of the Real West as a stage.

everything to fit a Montana setting because she was convinced no reader would buy a western novel set in Idaho. The land of Famous Potatoes didn't evoke the same emotional response as Big Sky Country. I couldn't help pondering if when Congress appropriated a third of Idaho to create Montana in 1864 it didn't also remove our most compelling imagery of place.

The truth may be that Idaho landscapes are simply too diverse to fit any of the popular western stereotypes. Or the individual parts cannot be combined to form any recognizable whole. Even if they could, we Idahoans in typical fashion probably couldn't agree on what our state's overarching image should be. Maybe some variation on scenic potatoes will remain the essence of popular perceptions of Idaho.

Early spring on a farm east of Clark Fork, April 1993.

SEVEN LANDSCAPES THAT DEFINE IDAHO

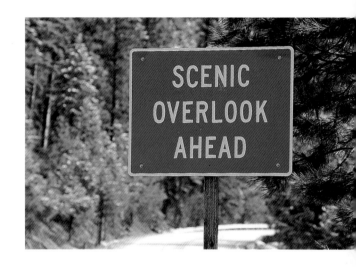

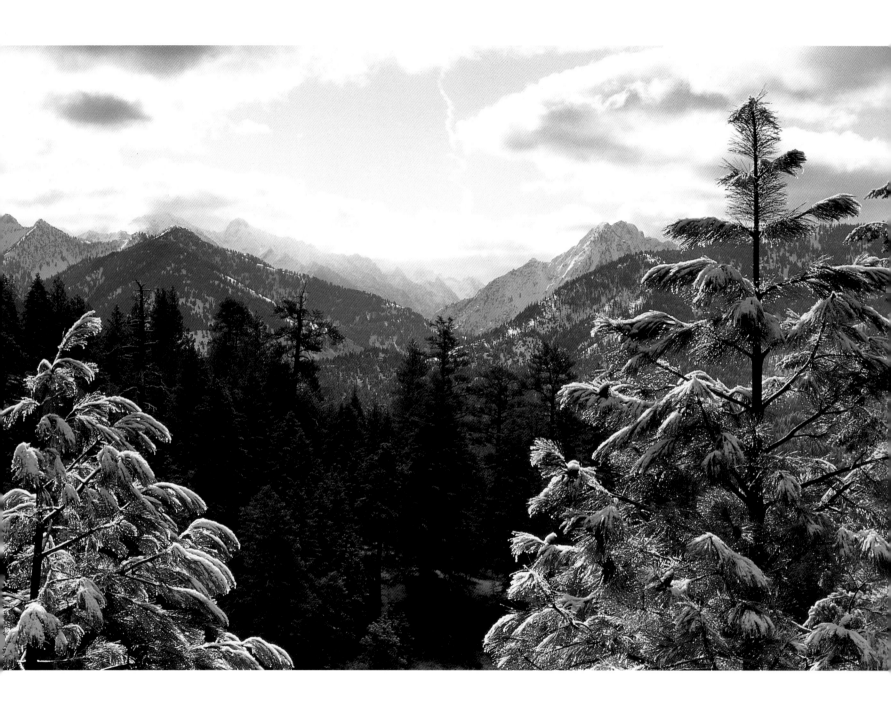

CHAPTER ONE NATURE'S OMNIPRESENCE

A KEY REASON WHY unpopulated space will continue to define the Idaho character for years to come is that the federal government still owns sixty-four percent of the land, and most of this area will likely remain off limits to permanent settlement. This means that even the state's largest population centers will continue to lie at the edge of a sprawling outback that intensifies an Idahoan's sense of nature's omnipresence. This is still true even for Boise, the Gem State's largest city, which had a population of 125,738 residents in 1990. "In southern California, if you want to go fishing, it's a three-day event," observed one recent arrival. In Boise "it may take you as much as two hours."

Of the state's fifty-three million acres, only about one-third of one percent are urban. Either blessed or cursed with an enormous amount of land always surrounding them, it is not surprising that Idahoans have come to value their attractive and varied natural setting almost as a birthright.

At the dawn of the twentieth century a mere six percent of all Idahoans lived in urban areas (communities the federal census defines as having 2,500 or more

(OVERLEAF)

Scenic overlook ahead on Highway 21 near Grandjean, April 1995.

(OPPOSITE)

View from the overlook: Sawtooth Mountains framed by fresh snow on ponderosa pines, April 1995.

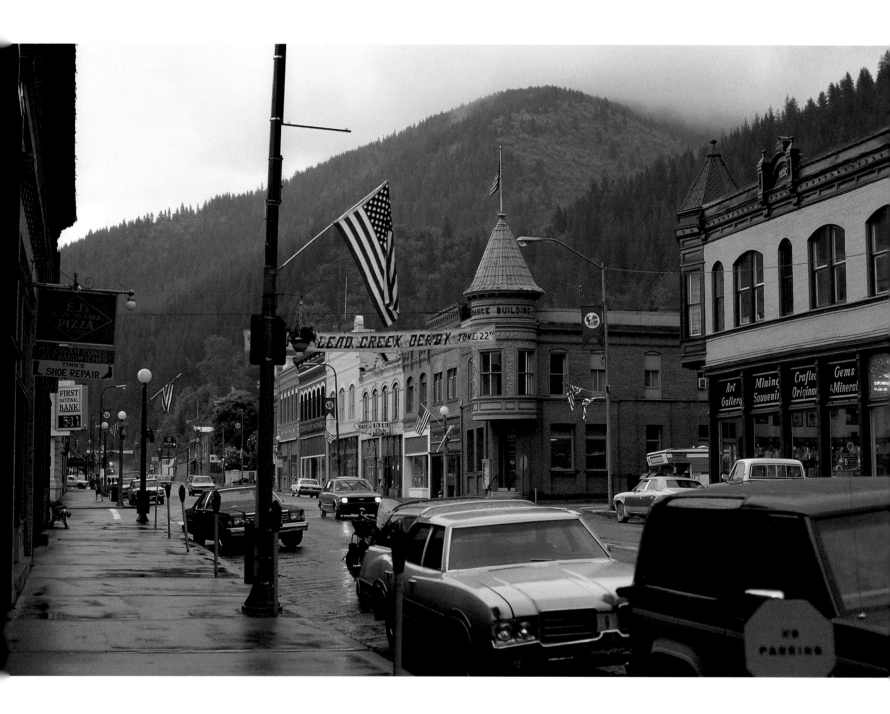

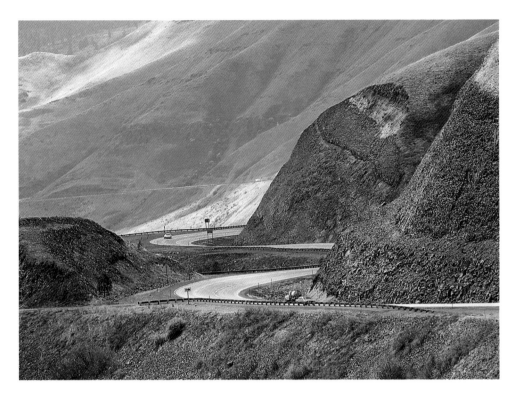

Modern Whitebird Grade and U.S. Highway 95, November 1992. During winter months when snow makes highway travel difficult, an occasional rock or snow slide may block Whitebird Grade and force motorists to make lengthy detours through neighboring states.

(OPPOSITE)

Downtown Wallace is decorated for the Fourth of July in 1985. Juxtaposition with omnipresent nature defines urban Idaho. Easy access to mountain slopes and seemingly pristine rivers from population centers remains crucial to what residents regard as a desirable lifestyle. "Throughout Idaho are men who have settled in the state and natives who refuse to leave simply because the rewards of living there are greater than the greater money they might make outside. They like small-towns and small-city associations, and they like free space, and they fill their eyes with grandeur and their ears with the great silence of the mountains." A. B. Guthrie, Jr., penned that description in the 1950s and it remains largely true today, even in booming Boise where a trout stream and river-rafting are available only minutes from the state capitol and downtown high-rise buildings.

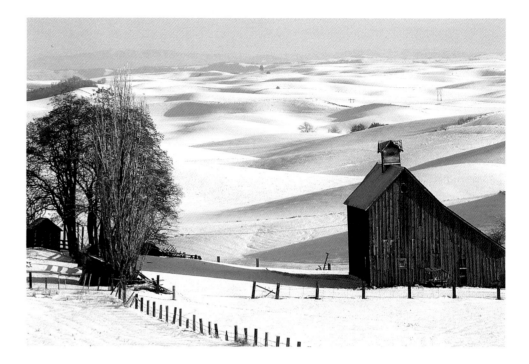

Winter landscape on a farm south of Moscow, December 1992, where snow looks like whipped cream on the rolling hills of the Palouse prairie. If a state is defined as rural by the number of people living outside standard metropolitan statistical areas, then in recent years Idaho still ranked (with Vermont and Montana) among the three most rural states in the United States. Not surprisingly, the Gem State's number one source of income in the 1990s was agriculture, as it has been since statehood.

residents). That was the lowest figure for any state in the West. Ninety years later Idaho was fifty-four percent urban compared to the national average of seventy-four percent, yet it still contained only three cities of thirty thousand or more residents—Boise, Pocatello, and Idaho Falls—and all three were situated on the Snake River plain. What was remarkable about this comparison is that only in 1970 did Idaho become more urban than rural. The nation as a whole crossed that statistical divide fifty years earlier. We Idahoans never rush into anything.

THROUGH A SEA OF MOUNTAINS

Except for the Snake River plain, Idaho is one vast sea of mountains, nearly eighty ranges in all, broken only by infrequent islands of farmland, such as the Camas Prairie and Palouse hills of the northern panhandle. The highest point in

Sherman Saddle, August 1992, in the Bitterroot Mountains on the route followed by Lewis and Clark in 1805–6. Water is Idaho's single most valuable natural resource. This rivulet will eventually flow into the Columbia River and Pacific Ocean.

Idaho is Mount Borah at 12,662 feet; the lowest is Lewiston at 738 feet. The average elevation is approximately five thousand feet above sea level; only four states are higher. If somehow Idaho's vertical surfaces could be rolled flat, one wit has observed, it would become the largest state in the union.

But Idaho without its mountains is inconceivable. The land in southcentral Idaho is uplifted into a series of jagged peaks aptly named the Sawtooths, while the sinuous Palouse hills resemble ocean swells as they roll toward distant horizons. High mountains along the Salmon River divide Idaho and prevent easy communication and transportation. The only alternative within the state to the serpentine two-lane Highway 95 between north and south is a backcountry trail suited in summer mainly to four-wheel drive vehicles and blocked by snow much of the rest of the year. Even Idaho's flat places can still be described as lying within the mountains' shadow, and no place escapes the influence of mountain ranges on weather patterns, vegetation, and economic activities.

The typical climate of northern Idaho is maritime, while that of southern Idaho is continental. During the winter months moist air from the Pacific Ocean often blankets the panhandle. Summers, by contrast, are relatively dry, and residents of places like Moscow and Lewiston must water their lawns to keep them green. August is a time of great forest fire danger across the state.

Even with the dramatic swings between wet and dry seasons, Idaho still has more extensive water resources than any other state of the mountain West, receiving nearly a hundred million acre-feet of water each year in the form of rain and snow. That is enough water to cover a hundred million acres of land to a depth of one foot. A more revealing statistic is that eight percent of the total irrigated land in the United States is located within Idaho, mainly along the Snake River plain. It is the destiny of several of the state's rivers to end up mainly as irrigation canals and ditches.

Of the state's many rivers—from the Boise, Bruneau, and Blackfoot in the south to the St. Joe, Clark Fork, and Kootenai in the north—none serves Idaho in a greater variety of ways than the Snake. Originating in a remote canyon spring just south of Yellowstone National Park, the Snake traces a crescent-shaped course across southern Idaho, where it transforms an expanse of aridity

Sunset on the Clark Fork River east of Lake Pend Oreille in early May 1994.

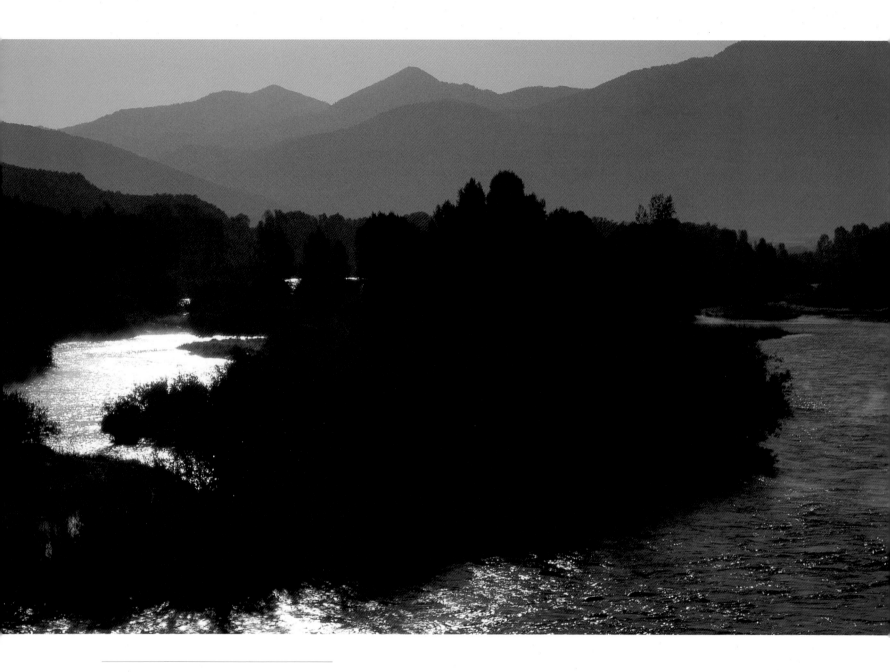

First light creates island silhouettes in the Snake River near Swan Valley, August 1994.

and stone into more than three million acres of irrigated land. Then as the river approaches the Oregon border, it swings abruptly north and plunges into Hells Canyon, the continent's deepest gorge. Thirty miles long and in places 7,900 feet deep, one-third of a mile deeper than the Grand Canyon, Hells Canyon compresses the Snake River into a maelstrom of white water that terrorized early explorers and effectively blocked river communication between northern and southern Idaho. Located on opposite sides of the state, Lewiston and Idaho Falls share the Snake River, but numerous rapids and waterfalls insured that no steamboat would ever connect them.

The thousand-mile-long waterway drains more than a hundred thousand square miles of land before it joins the Columbia River in southcentral Washington. Most of Idaho's annual precipitation either evaporates or returns to the ocean via the Snake River, but not before dams harness it to generate electric

Dawn illuminates hawkweed, a plant native to the Bitterroot Mountains, near Indian Post Office, August 1990.

power and irrigate crops. In the volume of water it carries and the area it drains, the Snake ranks sixth among the rivers of the United States; within fifty miles of its banks lives half the population of the Gem State. Only the northern portion of the panhandle and the extreme southeast are not drained by the Nile of Idaho.

Because of its rugged terrain and divided character, Idaho is a state that will always defy easy geographic classification. The well-watered panhandle, with its lakes, extensive forests, and fields of grain, blends readily into eastern Oregon and Washington, with which northern Idaho has many ties of commerce and communication, while the arid south is often indistinguishable from neighboring portions of Nevada, Utah, and Wyoming, in addition to the Oregon desert. Not surprisingly, some Idahoans perceive their state as oriented toward Oregon, Washington, and the Pacific rim, while others consider it part of the Intermountain West. One thing all Idahoans do have in common is their remoteness from where most other Americans live.

A DISTANT SOLITUDE

Omnipresent nature not only defines the landscape encompassed within the present boundaries of the Gem State, it also includes the odd spatial relationship that resulted when more than a thousand miles of mountains and plains isolated Idaho from the nation's main population centers, or even from national consciousness. Throughout much of its history Idaho remained a remote place; the main currents of American history frequently passed it by.

From 1805, when members of the Lewis and Clark expedition became the first whites to enter the land destined to become Idaho, until the 1860s, the forbidding terrain and its native inhabitants were of little interest to all but a few fur trappers, explorers, and missionaries. Idaho's rugged mountains brought Lewis and Clark to the brink of ruin, and its desiccated Snake River plain drove a thirsty band of fur-seekers known as Astorians nearly insane. Similar torments awaited later explorers and fur traders.

Travelers on the Oregon Trail, which crossed the southern part of the state,

hurried across the Snake River plain in the 1840s and 1850s as fast as they could on their way to western Oregon. Emigrant parties invariably reached Idaho during the hottest part of summer, having already endured nearly 1,300 miles on the trail. Their animals were tired and thirsty, but the cool waters of the Snake River lay far below the canyon's rim, so tantalizing and yet so impossible to reach. Moreover, the sharp-edged basalt lacerated the hooves of draft animals.

During the heyday of the Oregon Trail, from the 1840s to the 1860s, few if any emigrants stopped short of the Willamette Valley to establish a permanent

Sagebrush-covered plains stretch as far as the eye can see: Craters of the Moon National Monument, August 1994.

home on the dry Snake River plain. As a result, Idaho was settled mainly by the backwash of people who had already gone west to the Pacific or by those who moved north to the outer fringes of the growing Mormon colony on the Great Salt Lake. Not until 1860 did Idaho get its first town, although the pioneers who founded Franklin insisted that they were still within Utah until a formal survey of the boundary in 1871 forced them to concede that their settlement was indeed under Idaho's jurisdiction.

Not until discovery of precious metals in the early 1860s did whites show much interest in settling the land that became Idaho. Actually, settling the land is a misnomer. Initially these pioneers clustered together like bees in a few urban hives formed by the scattered mining camps and supply points that typified the territory's first communities. Many people remained in Idaho only long enough to seek their fortunes.

As Idahoans improved their methods of transportation and came to terms with the often harsh natural landscape that surrounded their early settlements, they came to value omnipresent nature both for its beauty and its recreational opportunities. Almost from the day Boise was platted in 1863, following the discovery of gold nearby, camping was popular with families who headed into the mountains for two or three days of hunting, fishing, and hiking. Not surprisingly, over the years Idahoans adopted or invented a host of outdoor-oriented activities. Their continuing love affair with the great outdoors has been worth a considerable amount of money, and that amount continues to grow. The list of lucrative outdoor activities in Idaho today includes backpacking, fishing, hunting, whitewater rafting, downhill and crosscountry skiing, golf, and swimming.

Nature's prominence was directly responsible for creating two of Idaho's other defining landscapes. Corridors—especially the pack trails, railroad lines, and highways that linked isolated communities together—constituted a landscape distinct from its environs. With improved transportation and communication links it became possible to transform omnipresent nature into a landscape of opportunity. But first there was the matter of borderlands.

I spent a week in August 1994 rafting on the main Salmon River with Omer and Elaine Drury. Now retired after practicing medicine for several decades in Troy, Omer is among Idaho's commercial rafting pioneers. Rafting and other whitewater sports add millions of dollars each year to the Gem State's economy. Idahoans today retain a high regard for the quality of life, especially when it is measured not just in terms of per capita income (where Idaho has never ranked high) but also in terms of room to roam, clear skies, and mountain grandeur.

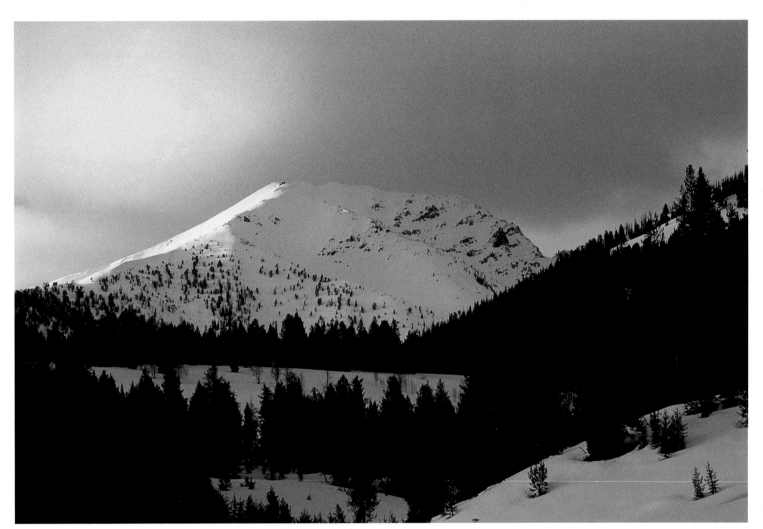

A mountain sunset south of Galena Summit on Highway 75, April 1995.

BORDERLANDS:
FROM BOUNDLESSNESS TO ORGANIZATION

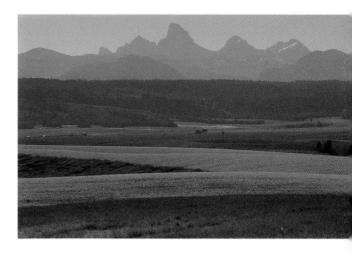

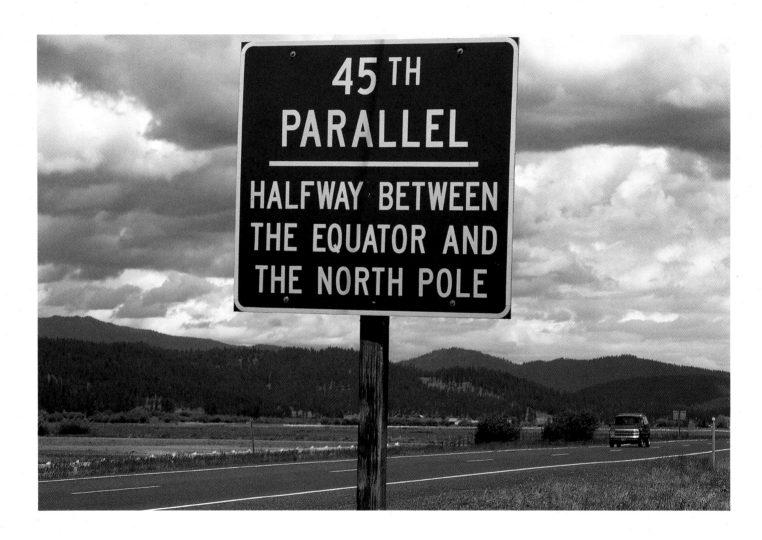

CHAPTER TWO BORDERLANDS: FROM BOUNDLESSNESS TO ORGANIZATION

BORDERS, SEEMINGLY WITHOUT NUMBER, stretch across the Idaho landscape to parcel it into counties, cities, national and state forests, parks and monuments, and even soil and water conservation districts. A sign posted along U.S. Highway 95 marks the 45th parallel, the line of latitude equidistant from the Equator and the North Pole. The state's own boundaries are precisely defined by law, and some stretches are quite dramatic: Hells Canyon forms what may be the most spectacular border in the United States, separating Oregon and Idaho.

The southern boundary of the Gem State stretches along the 42nd parallel for three hundred five miles, and the northern one traces the Canadian border along the 49th parallel for forty-five miles. In between lies land compressed by a contorted eastern boundary into an odd shape that on the map of the United States resembles a hatchet leaning against a wall, or a pork chop.

But any border, no matter which way it runs, always represents far more than a mere line. It is statement of relationships that reveals how, for example, a culture chooses to distribute land and add a human dimension to an amorphous natural landscape. Idaho's many borders illustrate the way Euro-American new-

comers imposed organization on what they perceived to be the landscape of omnipresent nature. In this way any border becomes both a way to organize boundless space and a distillation of history and culture.

Lines drawn on a map are given visible expression by fences, and official markers define basic differences between Indian and Euro-American world views. For the pioneer white settlers—who regarded the land as a wilderness divided only at the distant horizon between earth and sky—the process of organizing space by extending borders across it went hand in hand with naming the various parts they enclosed. A borderland is not merely the perimeter that encloses the modern state of Idaho; it includes the overlay of names and lines of demarcation that Euro-Americans imposed on the unfamiliar land they encountered. Thus every part of modern Idaho is in some sense a borderland that dates back at least to the territory's creation in 1863. Historic place names and boundaries define modern Idaho space.

However, the unknown and boundless land destined to become Idaho appeared unknown and boundless only to the Euro-Americans. It had been home to Native Americans for countless generations. The names the newcomers gave to the space they "discovered," like the lines they drew across it, were both acts of appropriation. Even when Euro-Americans attempted to preserve what they understood to be Native American names, they were not always successful. Lewis and Clark retained the Nez Perce name Kooskooske, but those who followed them called it the Clearwater River. Ironically, even the name Idaho, once thought to be of Indian origin, actually isn't.

Sign for Bureau of Land Management in the remote Pahsimeroi Valley, May 1995.

DON'T BLAME DRUNKEN SURVEYORS

At Red Rock Pass in northeastern Idaho a traveler will cross from the Atlantic to Pacific side of the continental divide by going *east* from Montana into Idaho. The first time I did so, I found the experience totally disorienting. In the United States a person does not think of driving east to reach the Pacific Slope, but along the Idaho-Montana border that happens.

One example of Idahoans' self-deprecating humor is the story we commonly tell to explain how our state's eastern border came to defy common sense. The tale is totally untrue, but we validate it through frequent retelling. We blame the whole border mess on drunken surveyors, who got lost and followed the Bitterroot divide north from Lost Trail Pass instead of the continental divide through what is now western Montana.

In truth, surveyors had nothing to do with defining Idaho's odd shape. The official survey of the Montana-Idaho border was actually completed in two sections, the northern panhandle in 1899 and along the Bitterroots and continental divide between 1904 and 1907. That was more than thirty years after Congress had last adjusted the Idaho boundary. Moreover, because the surveyors began at the Canadian border and worked their way south, it would have been impossible for them, drunk or sober, to make a U-turn and head north again at Lost Trail Pass. The meandering boundary line was actually drawn by members of Congress, presumably sober.

Quite simply, there was no compelling reason why Congress should have designated any part of the American landscape as Idaho. Its creation in 1863 defied historical, geographical, cultural, and social logic. It met the criteria of political expediency only, and that may be about the same as saying it had no logic at all. Congress created Idaho mainly to placate the politicians of Olympia, Washington, who feared the capital might be moved farther east after gold discoveries in the northern Rocky Mountains complicated political life in sprawling Washington Territory.

The frontier village of Walla Walla emerged as a major supply point for the mining camps and soon grew to be the largest settlement in Washington Territory. Another potential rival to Olympia was Lewiston, gateway to the Clearwater diggings. Olympia politicians were only too glad to have Congress combine Washington's remote mining regions into a sprawling new territory called Idaho, created on March 4, 1863, when President Abraham Lincoln signed the bill into law.

At that time Idaho extended across an area one-quarter larger than Texas and seemed little more than a temporary holding facility for land that no other state

Red Rock Pass at the Montana-Idaho border west of Henry's Lake, October 1994.

Lost Trail Summit, at an elevation of 6,995 feet on Highway 93, July 1992.

or territory wanted or knew how to govern. Within expansive boundaries that stretched both east and west from the continental divide lived a non-Indian population of 30,559 men and 1,089 women scattered among a hodgepodge of mining camps and farm villages so remote that scarcely a trail connected them.

The new territory lacked lines of transportation and communication to bind it together as well as money and effective government. In this unsettled situation, the forces of lawlessness grew so bold that in one celebrated case the county sheriff himself headed a gang of plundering highwaymen. When citizens of Virginia City and Bannack, then in Idaho, could tolerate no more lawlessness, they organized themselves into vigilantes and summarily hanged Sheriff Henry Plummer and his chief henchmen. On the gallows they placed a placard around Plummer's neck that read: "3-7-77: Last Warning to Evil Doers." (The number may refer to the dimensions of a grave.) Montanans are so proud of this incident that today every one of their state patrol car carries the cryptic "3-7-77" on its doors. I only wonder how many Montanans realize that a law enforcement agency uses a symbol of extra-legal vigilantism, or that the celebrated incident actually took place when Montana was part of greater Idaho?

Legislators from the upper Missouri River area found it nearly impossible to reach the Idaho capitol at Lewiston, and territorial officials faced a similar challenge when they sought to administer their vast domain. Thus it should not be too surprising that when members of Idaho's first legislature finally assembled in Lewiston in December 1863, they unanimously petitioned Congress to divide the territory to make it easier to govern.

Even after the creation of Montana on May 26, 1864 greatly diminished Idaho's size, it still encompassed a portion of future Wyoming west of the continental divide. Alas, Congress was not yet done tinkering with the shape of Idaho: on July 25, 1868, federal lawmakers shrank Idaho to its present contorted dimensions by carving away the southern portion of Yellowstone Park, all of the Grand Tetons, and a portion of the oil and coal-rich Green River country, an area that could today be pumping tourist and energy dollars into the Gem State's treasury instead of Wyoming's.

As long as Congress was rearranging the boundaries, it was difficult for residents to develop any emotional attachment to a place called Idaho. Without having

to relocate physically, a person living on the upper Missouri River would have
been a Nebraskan in early 1863, an Idahoan in late 1863, and a Montanan in mid-
1864. That's an extreme case, but no one present at the creation of Idaho could
have predicted with any accuracy how the territorial boundaries would look in ten
years, much less a quarter century later. Even after Congress shrank Idaho for the
last time in 1868, a complex maze of mountains and canyons along both sides of
the Salmon River separated the peculiarly shaped territory into two distinct parts.

Unlike the situation in Massachusetts or New York or Texas, where geography
and history combined to provide residents some measure of common ground,
nothing but the shaky logic of political expediency provided a foundation for
Idaho Territory to build upon. The amazing thing was that Idaho had not disap-
peared long before it became a state on July 3, 1890.

HEAD FOR THE BORDER

Members of Congress drew boundaries on a map and gave the enclosed space a
name, but it required the people who actually called themselves Idahoans to
breathe life into the federal lawmakers' new creation. That proved no easy task.
Few residents were satisfied with the arbitrary union.

Even before Euro-Americans arrived, Indians of the interior plateau north of
the Salmon River and those of the Great Basin desert south of that historic divide
evolved as two different cultures. Euro-American newcomers seemed likely to
perpetuate those geographical differences by the way they initially drew their
boundary lines. When, for instance, Washington became a territory in 1853, it
encompassed the northern part of future Idaho while Oregon retained the
southern portion. Early trails and roads across Idaho ran mainly from east to
west, not north to south.

Because of the peculiar configuration of its borders, Idaho was a state that
clearly went against the grain. Consider that almost all states west of Minnesota
exist in pairs: North and South Dakota, Montana and Wyoming, Washington and
Oregon. Each one is oriented along early east-to-west lines of transportation and
trade. All alone is Idaho, extending from north to south in a manner that clearly

*A stone and concrete pillar anchors the Idaho-
Utah border along Highway 89 south of Fish
Haven, October 1994. This, one of the most sub-
stantial boundary markers I've found along the
perimeter of Idaho, seems to fix firmly a once
wayward portion of the border.*

defies established transportation links. This made for deep and enduring divisions.

During the territorial years (1863-1890), no fewer than four sessions of the Idaho legislature petitioned Congress to annex the northern panhandle either to Washington or to Montana. When Washington held a constitutional convention in Walla Walla in 1878, delegates from the Idaho panhandle attended.

Nothing came of the Walla Walla constitution, but in 1886-87 both houses of Congress finally approved a measure severing the panhandle from the rest of Idaho and reattaching it to Washington. Citizens of Lewiston, nursing a grudge that dated from removal of the territorial capital to Boise in 1865, greeted news of their impending return to Washington with brass bands and a community celebration. But their revelry was cut short four days later when they learned that President Grover Cleveland had pocket vetoed the bill because of protests by Idaho's territorial governor, Edward A. Stevenson. The president's failure to sign the bill so angered residents of the north that when the 1889 Idaho territorial legislature met, it created a public university and placed it in the panhandle town of Moscow, a gesture specifically designed to offer an "olive branch" of peace. The new state constitution soon confirmed the location. Once again, political expediency defined basic spatial relationships in Idaho.

Since that time the panhandle has remained a part of Idaho, though it is physically attached to the rest of the state only by the most tenuous of transportation links. There has never been a rail line connecting north to south, at least not within the state's boundaries. During the heyday of railway passenger service, from the 1880s through the 1920s, travel by train from Lewiston, Coeur d'Alene, or Sandpoint to Boise always meant a circuitous trip as far west as Umatilla or Pendleton, Oregon. Not surprisingly, at the turn of the century it took residents of northern Idaho longer to reach their own state capitol than the capitols of either Washington or Montana.

The highway alternative was scarcely better. As early as 1872 Idahoans had dreamed of a military road connecting the two sections, but nothing came of the proposal. After completion of a highway in 1919, a Coeur d'Alene writer optimistically predicted, "North and South Idaho are destined to join the ranks of obsolete terms." But such was not to be.

In many ways the panhandle region remains farther from the thinking of

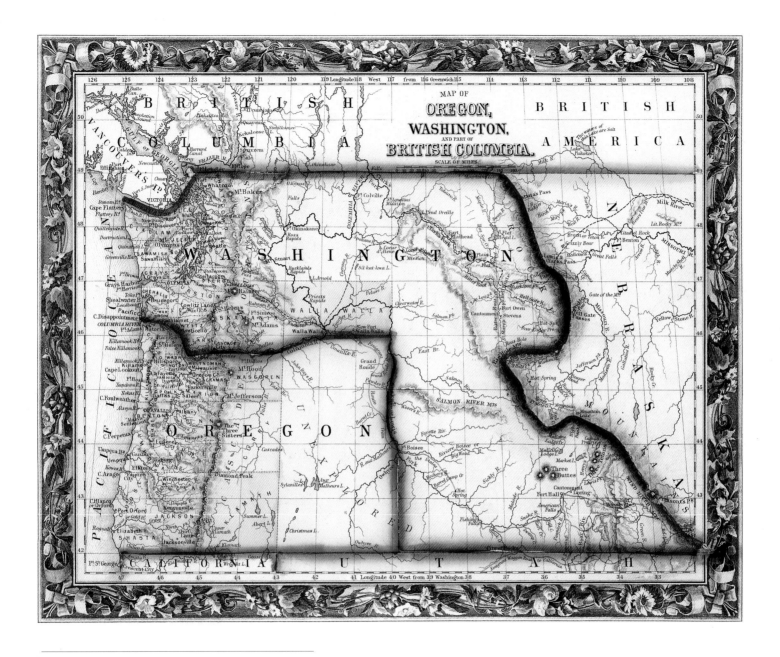

The land destined to become Idaho formed the eastern part of Washington Territory in the early 1860s. Courtesy: Special Collections Division, University of Washington Libraries, N979.5, map #54.

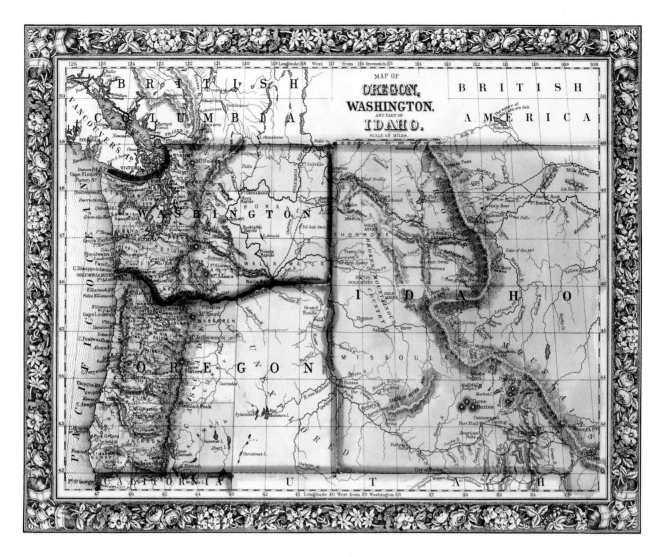

A map of greater Idaho in late 1863 or early 1864. Courtesy: Special Collections Division, University of Washington Libraries, N979.5, map #58.

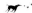

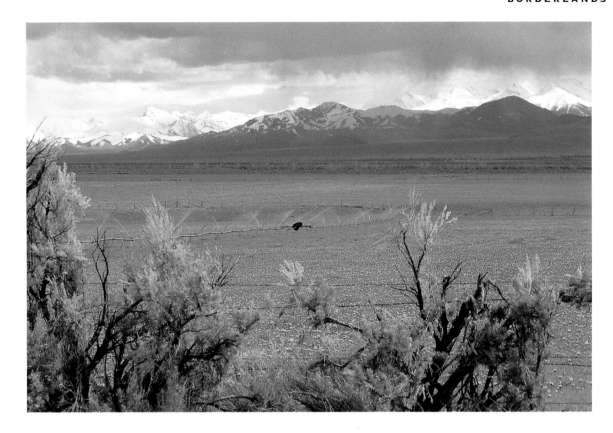

Big sagebrush nearly overwhelms a fence in the Pahsimeroi Valley, May 1995. In the distance are the peaks of the Lost River Range, which contains Idaho's highest elevation, 12,662 feet.

southern Idaho residents than either Utah or Nevada. I suspect a good many people in the south have never been north of McCall or New Meadows and don't see any reason to go. To them northern Idaho is basically irrelevant. Northerners will often return the sentiment.

To me it is a curious commentary on the psychological distance that separates the panhandle from the rest of Idaho when residents of the state's ten northern counties describe the area as "North Idaho"—as in North Dakota or North Carolina. They will typically speak of east*ern* Oregon or east*ern* Washington or even south*ern* Idaho, but most often they say "North Idaho," as if to emphasize the separatist connotation that dates from a century earlier. In fact, some in the north have come out with wry bumper stickers that proclaim: "North Idaho: The 51st state." These are little more than attention getters.

Spring flowers—mule's ear and little sun-flower—festoon the Camas Prairie near Grangeville, June 1993. Around Fairfield in southern Idaho is another panorama called Camas Prairie.

NAMING THE LAND

Like boundary markers, place names represent a way to organize a seemingly boundless natural landscape. Today they not only serve to orient us, but almost every one of them contains a story that refines our sense of place. Some stories are biographical; some are capsule histories. The counties of Nez Perce and Shoshone and the communities of Pocatello and Kamiah recall the first Idahoans.

Another set of names, Lewiston, Owyhee, and Lemhi, recall another phase of Idaho history: the era of explorers, fur traders, and missionaries.

The name "Idaho" itself is widely claimed to translate into an Indian word for "light shining on the mountains." It actually means nothing at all. "Idaho" dates from a time when Indian-sounding names were often created by whites touched by the poetry of Longfellow and others who possessed a romantic turn of mind.

When the bill to create the new territory passed the House of Representatives it actually carried the name "Montana." In the Senate, Henry Wilson of Massachusetts moved that it be changed to Idaho, saying "'Montana' is no name at all." Defeated at first, Wilson renewed his argument, which Benjamin Franklin Harding of Oregon supported, saying, "I think the name of 'Idaho' is much preferable to 'Montana.' 'Montana' in my mind signifies nothing at all. 'Idaho,' in English, signifies 'Gem of the Mountains.'" After only a few more moments of deliberation, Senators assented to the new territory of Idaho by a vote of 25 to 12.

One of the steamboats that transported gold seekers up the Columbia River in the early 1860s was named *Idaho*. Its owners claimed to have gotten the name from a Colorado mining man. Indeed, Colorado had almost been named "Idaho," and it was a citizen from that would-be territory who first coined the word "Idaho," claiming it was of Indian derivation. Until research in the late 1950s rediscovered the truth that "Idaho" was an invented word, several generations of Idahoans had been taught that it was derived from the Indian words "E Dah Hoe." Any meaning ascribed to the name "Idaho" ranks in the same category as the tale of drunken surveyors muddling up the eastern boundary.

The name "Idaho," like the emergence of the territory itself in 1863, was basically the product of chance and not any a long-term historical trend. In a real sense, modern Idaho had to be "invented" during the nineteenth and early twentieth centuries, unlike some of the original American colonies. These, in contrast, evolved from the first tiny settlements along the Atlantic seaboard over a period of generations, spreading inland only gradually, often along a single river valley. In the process of inventing Idaho, names of various types formed an integral part of the borderland landscape that defines the modern Gem State.

LIFE ON THE VERGE

Boundary lines, together with place names, redefined the landscape of the Gem State. But not all borderlands were of human creation. Idaho today is full of verges, those visually arresting places where two distinct landscapes intersect. The serrated eastern edge of the Palouse country where forest meets prairie offers a particularly vivid example of this phenomenon. Other verges exist wherever mountains encounter lakes. Some are formed where city and country, or industry and nature, intersect. Fences often define a verge. Some of the most dramatic yet elusive verges exist at the extremities of weather systems. At the edge of a thunderstorm or fogbank is where landscape photographers frequently find the most breathtaking natural illumination.

Looking east through a rustic gate off Highway 75 south of Stanley, April 1995.

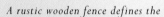

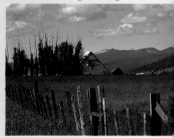

A rustic wooden fence defines the landscape along a country road near Roseberry east of Donnelly, June 1993.

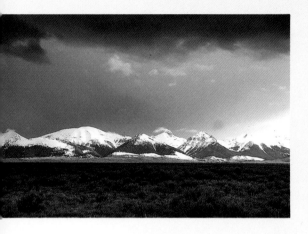

At the verge of a thunderstorm: the Lemhi Range near Gilmore, May 1995.

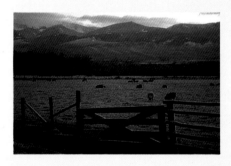

The rising sun has yet to top the continental divide south of Salmon, November 1991.

The international boundary at Porthill, May 1994.

Entering Harvard, May 1994. When the tracks of the Washington, Idaho & Montana Railway headed west from Palouse, Washington, into the white pine country of the Idaho panhandle, they came first to the new milltown of Potlatch (meaning "great feast") and then to Princeton. The next town was called Harvard. This set a pattern for naming the rest of the town sites: Yale, Stanford, Vassar, Cornell, Purdue, and Wellesley. Most were chosen by young college men who surveyed the right of way and supervised construction. Despite the impressive appellations, few of the places ever amounted to more than lonely railroad sidings.

There's no mistaking Leadore (population less than a hundred on a good day) either from the ground or air, May 1995.

A modern wire fence glistens in the morning light above Lewiston and the Clearwater Valley, October 1991.

Names on the Land: Idaho Counties

County	Date of Organization	Origin of Placename
Created by Washington Territorial Legislature		
Shoshone	January 9, 1861	Shoshoni Indians
Idaho	December 20, 1861	*See previous discussion*
Nez Perce	December 20, 1861	Nez Perce Indians
Boise	January 12, 1863	Boise River (French: *Les bois*, the woods)
Created by Idaho Territorial Legislature		
Owyhee	December 31, 1863	Refers to Hawaiian Islanders, laborers employed in the Northwest fur trade
Oneida	January 22, 1864	Lake Oneida, NY
Ada	December 22, 1864	Ada Riggs, first white child born in area
Kootenai	January 9, 1867	Kootenai Indians
Lemhi	January 9, 1869	For Limhi (sic) in *Book of Mormon*
Bear Lake	January 5, 1875	Bear Lake
Cassia	February 20, 1879	Cassia Creek
Washington	February 20, 1879	Pres. George Washington
Custer	January 8, 1881	Gen. George Armstrong Custer
Bingham	January 13, 1885	Congressman Henry Harrison Bingham of Pennsylvania
Elmore	February 7, 1889	Ida Elmore mines
Created by Idaho State Legislature		
Canyon	November 26, 1892*	A canyon of either the Snake or Boise rivers
Fremont	March 4, 1893	Gen. John C. Fremont, explorer
Bannock	March 6, 1893	Bannock or Bannack Indians
Blaine	March 5, 1895	James G. Blaine, U.S. Secretary of State
Lincoln	March 18, 1895	Pres. Abraham Lincoln
Bonner	February 21, 1907	Edwin L. Bonner, early ferryboat operator
Twin Falls	February 21, 1907	Twin Falls of Snake River
Bonneville	February 7, 1911	Capt. Benjamin L. E. Bonneville, explorer
Clearwater	February 27, 1911	Clearwater River
Adams	March 3, 1911	Pres. John Adams

*Date of Proclamation

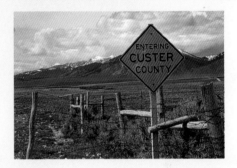

(TOP)

Entering Owyhee County by crossing the Snake River at Marsing, October 1991.

(BOTTOM)

At the southern boundary of Custer County, May 1995.

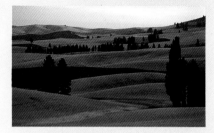

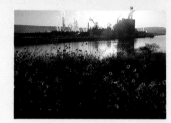

(TOP)

Boundaries of soil and water conservation districts in the Arbon Valley, October 1994.

(MIDDLE)

Verges between fields of wheat and stands of ponderosa pine add aesthetic appeal to the rolling Palouse country south of Moscow, Summer 1985. At larger verges early settlers found the land cheap, and if crops failed they could always chop cordwood for a living.

(BOTTOM)

The machine in the garden forms another type of verge. Morning sun reflects off sunflowers and the Clearwater River flowing by the Potlatch Mill east of Lewiston in October 1991.

Lewis	March 3, 1911	Capt. Meriwether Lewis, explorer
Gooding	January 28, 1913	Frank R. Gooding, Idaho governor and U.S. senator
Minidoka	January 28, 1913	Probably an Indian word, the meaning of which is uncertain
Franklin	January 30, 1913	Franklin Richards, prominent Mormon leader
Power	January 30, 1913	American Falls power plant
Jefferson	November 4, 1913+	Pres. Thomas Jefferson
Madison	November 4, 1913+	Pres. James Madison
Benewah	January 23, 1915	Coeur d'Alene chief
Boundary	January 23, 1915	Borders on Canada
Teton	January 26, 1915	Teton Range
Gem	May 18, 1915*	State nickname, "Gem State"
Butte	February 6, 1917	Topographical feature: buttes characteristic of area
Camas	February 6, 1917	Edible bulb used by Indians for food
Valley	February 26, 1917	Topographical feature: Long Valley
Payette	February 28, 1917	Payette River
Clark	February 1, 1919	Sam Clark, early settler
Jerome	February 8, 1919	Either for Jerome Hill; his grandson, Jerome Kuhn, Jr.; or his son-in-law, Jerome Kuhn; all developers
Caribou	February 11, 1919	Caribou Mountains

Created by United States Congress

Latah	May 14, 1888	Latah Creek

*Date of Proclamation

+Date of Referendum

Alturas county, no longer extant, was once larger than the state of Ohio.

Source: material on name origins compiled by the Idaho State Historical Society

ALONG CORRIDORS OF POWER

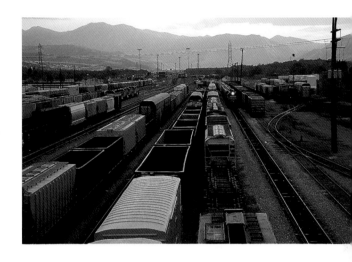

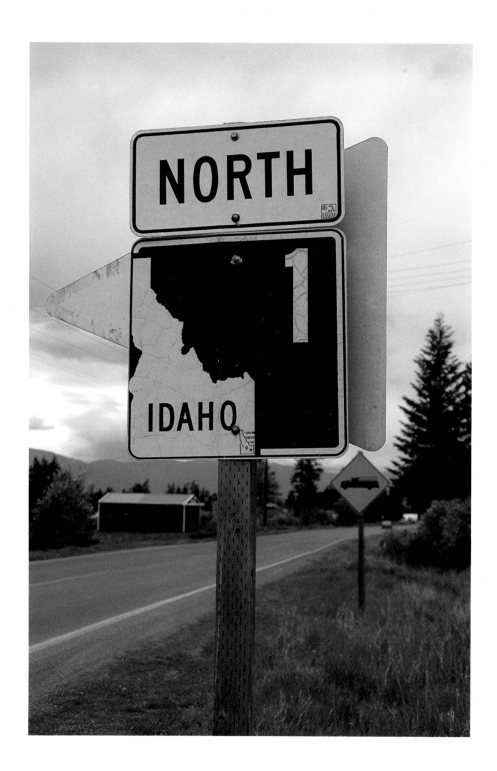

ALONG CORRIDORS OF POWER

ON ONE TRIP HOME from the East, the prospect of following the old Oregon Trail along the backroads of Nebraska and Wyoming offered me a welcome alternative to the mind-numbing stretches of Interstate 80. Near Scottsbluff I paused to ponder Chimney Rock, the eroded sandstone spire that was once a landmark on the way west. It provided a forceful reminder that not every landscape defining Idaho's place in history is actually located within the state's present boundaries—something especially true for corridors that once connected Idaho to the rest of the world.

If Chimney Rock were located almost anywhere else west of the hundredth meridian, where an eroded landscape is common, it would be unimpressive, yet because it stood as a sentinel beside the Oregon Trail it seemed to welcome emigrants to the new land. Its enduring fame illustrates how transportation and communication routes formed landscapes often quite distinct from the countryside through which they passed. Over time these corridors of power altered even distant landscapes as well through the new spatial arrangements they forged among regions.

(OVERLEAF)

Tracks of the Union Pacific Railroad form a corridor of power through Pocatello, September 1991.

(OPPOSITE)

Highway 1 north of Bonners Ferry, May 1994.

Improved methods of transportation and communication freed Idaho from the shackles imposed by distance and in the process rearranged both time and space. When the territory was formally organized in Lewiston on July 10, 1863, the United States had just fought two of the bloodiest battles in its history— Gettysburg and Vicksburg—to ensure survival of the Union; yet nearly two weeks passed before Idahoans learned of them. News "from the States" typically flashed west along the recently opened transcontinental telegraph line to California, plodded north by stagecoach to Portland, and then sailed east along the Columbia and Snake rivers aboard steamboats. It often reached remote mining camps by horse or mule. Idaho's first telegraph link with the rest of the country and its first transcontinental railroad lay several years in the future.

Any Idahoan who wanted to join the fight needed nearly a month to reach the battlefields of Virginia or Mississippi. The way east required several tiresome weeks of overland stagecoach travel or an equally time-consuming voyage by at least five different boats and a train portage across the isthmus of Panama.

For the first generation of Euro-American settlers, Idaho's isolation was a fact of life; it was palpable and often oppressive. In a land that Indians had called home for generations, many whites were bound by ties of kinship and sentiment to their former homes in the East or Europe, often making life very lonely and sometimes even unbearable for the newcomers. Not only was the new territory remote from America's economic and population centers, but its rugged terrain and widely scattered settlements discouraged effective communication and transportation links even within Idaho itself. Messages, people, and goods never traveled faster than a horse or steamboat, and often no faster than a plodding ox.

The words "Oregon Trail" invariably conjure up images of pioneer families struggling west by covered wagon. In the 1840s, the odyssey to Oregon (of which Idaho was then a part) meant leaving relatives and friends back east and undertaking a six-to-seven-month-long trek west to the Willamette Valley. This arduous, two-thousand-mile journey represented the longest overland pilgrimage that American settlers ever attempted.

The Oregon Trail has been described as the world's longest graveyard, with an average of one body buried every eighty yards. By some accounts, ten percent of

Sunset in the Snake River Canyon north of Twin Falls, October 1994.

the emigrants perished along the way. They lost their lives to swollen rivers, quicksand, rattlesnakes, buffalo stampedes, and on rare occasions, Indian attacks; children were occasionally crushed by wagon wheels or stepped on by oxen; and the number one killer on the trail was disease. For all this, if pioneers survived the hazards of the trail, they still had to deal with oppressive isolation once they reached their destination.

They had no easy way to send news of their safe arrival back to friends and relatives. During most of the 1840s no regular mail service linked Oregon with the rest of the world. The nearest post office was located in Weston, Missouri, and an eastbound traveler *might* carry letters to post them there. When mail finally reached its destination, recipients paid the delivery cost, for there were no prepaid stamps until the late 1840s.

After the federal government finally contracted for mail delivery between the

Atlantic and Pacific coasts in 1847, letters traveled from the East by ship to Panama, overland through disease-infested jungles, and then by another ship to the mouth of the Columbia River. In this way the first six sacks of mail reached Astoria's newly opened post office, a distribution center from which letters traveled inland by canoe and horseback.

Communication and transportation remained a problem throughout Idaho during the 1860s and 1870s, the era dominated by steamboat and stagecoach service. Not surprisingly, the weekly arrival of mail from distant points became a time of community celebration. In the early 1860s Wells Fargo delivered mail to Oro Fino City from Walla Walla, the main point of contact with the outside world until a post office opened at the Nez Perce diggings. One miner recalled the special day's excitement: "The head of a long procession of eager and impatient expectants, composed of all the various elements of the population, now begins to enter the door of the office." The express agent stood behind the counter, busily engaged in opening and classifying packages. "As soon as he can get ready, he begins to call the role, beginning with John Smith and proceeding upward or downward, to the right or to the left, as the case demands, and delivering letters, papers, and packages to each one as the names are responded to. As parties are served they file out into the street and others move up, and thus the work of delivering goes on." In this way each succeeding Sunday "would bring its quota of news from the battlefields in the distant East, and its alternating tide of joys and sorrows, hopes and fears."

Distinct seasonal rhythms caused the population to ebb and flow along the vital corridors that defined Idaho Territory. "Summer now wanes and blends into autumn," wrote William Goulder of the early mining camp of Florence. "The first of October comes bright, clear, and cold, with several inches of the new white winter dress covering mountain, hillside, and creek flats. The ice now begins to check the flow of water in the creeks. The nights begin to be too long and too cold and the days too short and often too stormy to allow placer mining, except on a much diminished scale, to be either comfortable or profitable. Gradually mining operations begin to be suspended or greatly restricted. Many of the miners, particularly those who have homes and families in the Walla Walla,

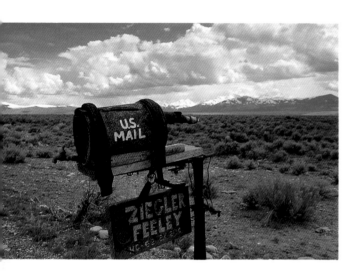

A mailbox in the Pahsimeroi Valley links a remote ranch to the outside world, May 1995. Decorated mailboxes are a type of folk art in rural Idaho.

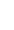

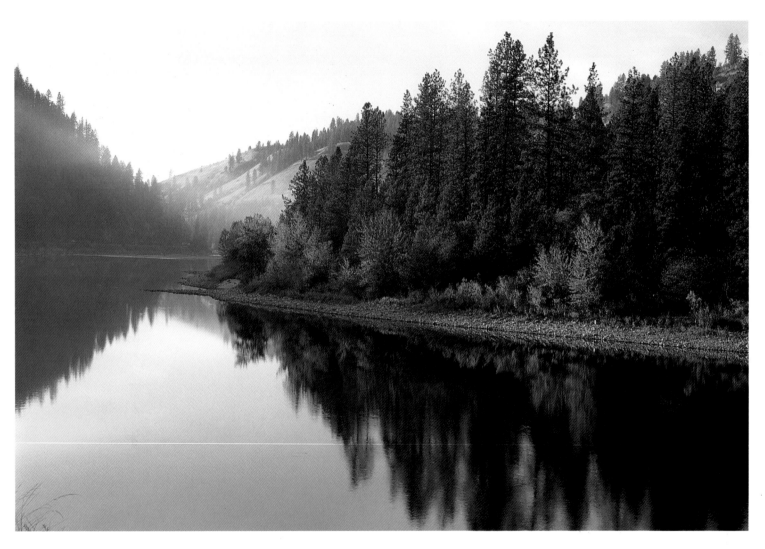

A tranquil stretch of the Clearwater River west of Orofino, October 1994.

Willamette, and other valleys in the lower country, begin to gather their ponies from the neighboring 'horse ranches' and prepare to abandon their camp until the following spring, when they would return to their claims and their labors. By the first of November, all who have elected to leave the camp for the winter have departed."

Florence was located high in the mountains above the Salmon River, where a deep blanket of snow accumulated and lasted a long time. Forty miles of mountain road had to be traveled to reach the camp. Prospectors' provisions and tools arrived by steamboat in Lewiston, the head of navigation on the Snake River, and were hauled by pack animals to the mines. Provisions could not be transported all the way during winter months, only to the foot of the mountains, from which point men carried them on their backs or on small sleighs or toboggans. At one time in 1861 and again in 1862, the price of flour climbed to one dollar per pound because of transportation difficulties. The prices of some groceries, such as sugar, tea, coffee, bacon, and tobacco, rose even higher. Not surprisingly, early Idahoans shared a keen interest in improved methods of transportation and communication.

PASSAGES

Trails of many different types threaded their way across Idaho. Some, including Indian trails, early roads, and railroad lines, were corridors used mainly for trade and commerce. Some, like those associated with Lewis and Clark, the Astorians, explorers Benjamin Bonneville and John C. Fremont, and the Pacific Railroad surveyors, were trails of discovery. Some were trails of human relocation, as was the case for the Oregon Trail and the trail of Chief Joseph and the Nez Perce during the war of 1877. And some, like the Mullan Road, were built for military purposes and used to extend the reach of the United States government across the Far West. These categories were not mutually exclusive.

The Columbia and Snake rivers, together with the Pacific Ocean, formed the earliest and easiest avenue for communication and transportation between Idaho

(OPPOSITE)

The steamboat Lewiston *once connected lower Snake River points to distant markets. Grain from Palouse fields traveled in the large burlap sacks seen here. Courtesy: Idaho State Historical Society, #693.*

and the rest of the world. Even so, water transportation between Lewiston or Umatilla (where a road across Oregon's Blue Mountains linked southern Idaho with Columbia River steamboats) and Portland was no simple matter. Formidable obstacles interrupted navigation at several places along the Great River of the West. Until the mid-1890s three separate steamboats were required to travel the nearly four hundred miles up the Columbia and Snake rivers from Portland to Lewiston, gateway to the mines of northern Idaho. Portage roads and railroads connected the steamboats at the Cascades (a stretch of white water) and The Dalles.

Within Idaho itself the waterways had a certain perversity about them. Most were navigable by steamboats only for relatively short distances. For this reason, early roads formed vital transportation corridors. Second in importance only to the Oregon Trail was the Mullan Road, a wagon route funded by Congress in the 1850s to connect Fort Benton, head of steamboat navigation on the Missouri River, and Walla Walla, near the navigable waters of the Columbia River. The road, which crossed the Idaho panhandle, was 624 miles long, and cost the War Department $230,000.

Stagecoaches, pack trains, and steamboats required little physical alteration to pass through the countryside. These modes of transportation generally adapted to the land as they found it. As a consequence, travel by stage was never without its trials. Early roads were often little more than dirt paths, and rain could turn long stretches into knee-deep quagmires. Still more alarming were the roads that wound down steep hillsides. Railroads, by contrast, bridged deep canyons and tunneled through mountains to rearrange both the space and time constraints that formerly isolated pioneer settlements. But railroad tracks remained an inconspicuous addition to the Idaho landscape until the early 1880s.

Even after completion of the nation's first transcontinental railroad at Promontory, Utah, in 1869, tracks did not extend beyond the southeastern corner of Idaho for at least another decade. Until then, merchandise crossed the southern part of the territory by stagecoach and freight wagon from Central Pacific Railroad stations at Kelton, Utah, or Winnemucca, Nevada. In the panhandle, steamboats brought goods from Portland to Lewiston where freight

wagons and pack trains distributed them to interior settlements. The prospect of a railroad link between east and west greatly excited Idaho's pioneer settlers.

There was no money for improvements during the 1870s when Idaho's economy and population growth were sluggish, but a dramatic change occurred during the early 1880s. Important new discoveries of gold and silver in the Wood River Valley of southcentral Idaho and the Coeur d'Alene River valley in the panhandle revived both the mining industry and the economy. Railroads could bring heavy machinery to tackle ever bigger mining jobs and move lower grade ores to distant markets. Also, with the coming of the iron horse, the price of food dropped.

RAILROAD CORRIDORS

"Magic" was a word often used to describe the results of complex feats of engineering that enabled the railroads of Idaho to bridge once impassable canyons and bore through mountain barriers. The twin ribbons of iron or steel redefined inhospitable terrain into friendly space, at least for people traveling by train. A trip for business or to visit friends and relatives became easy, and if a person went first class in one of the era's ornate sleeping cars the journey might actually be pleasurable. So luxurious were accommodations that some people who had struggled west in covered wagons in the recent past must have regarded the new mode of travel as almost sinful. Certainly the sense of isolation of pioneer days was gone.

Nowhere was the ease of train travel more obvious than across the arid spaces of the West. Wagons on the Oregon Trail followed waterways to reach the continental divide at South Pass; Union Pacific tracks, by contrast, took a more direct route across Wyoming and southern Idaho, plunging across waterless stretches of land that would have been the ruin of pioneers dependent on horses or oxen.

Railroads reoriented spatial relationships across the Idaho landscape by creating new towns and stimulating economic activity. Railroad connections across the United States and Canada gave everyday life in Idaho a whole new contour.

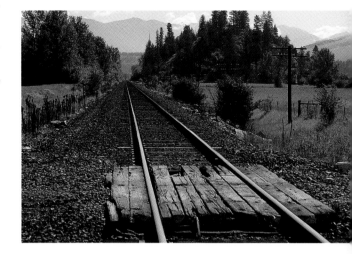

Burlington Northern tracks east of Bonners Ferry, July 1991. In the narrowest sense a railroad created a special landscape consisting of ties, rails, bridges, signaling systems, stations, and various industrial outbuilding. Yet something so basic as the tracks over which the trains ran represented the power of human knowledge to triumph over nature, to regularize the landscape into standard terms of curvature and elevation, and to shrink the vast differences across Idaho. The railroad possessed the power to forge new economic landscapes, a fact illustrated clearly in southern Idaho where together with irrigation, railroads made it possible to grow potatoes and sugar beets in areas formerly suited only to grazing sheep and cattle.

They opened distant markets to local products—especially the bulky products of fields, forests, and mines—and created new jobs and fortunes. But they also increased competition for local merchants. If prices on Main Street were too high, the twin rails made it possible for citizens of once-isolated communities like Montpelier and Coeur d'Alene to thumb through catalogs from Sears Roebuck or Montgomery Ward and order a watch made in Connecticut, a hat from Pennsylvania, or a dress from New Hampshire.

Passenger trains represented a way of shaping popular impressions of the western landscape. For travelers the vistas framed by car windows became the railway landscape. Across the plains of southern Idaho it was broad, extending from trackside to mountain ranges often fifty or more miles away. But threading the steep canyons of the Bitterroot Mountains, the railway landscape was scarcely wider than the tracks themselves. In either case, the location engineers determined what passengers saw of Idaho.

Even more impressive than the many physical or economic changes wrought by railroads in Idaho was the speed with which they transformed settlement landscapes. Within the span of a single generation, orchards and grainfields replaced vast stretches of sagebrush and bunch grass. Continuous blocks of cultivated fields and neat, substantial clusters of farm dwellings, barns, grain bins, cattle, and hogs vividly transformed the rural landscape. In several places, villages became small cities with the modern accouterments of electric lights, telephones, municipal waterworks, streetcars, cement sidewalks, brick and stone business blocks, and modern schoolhouses.

Today the railroads' physical signature written in track across Idaho is shorter and less visible than it was at its peak around World War I. The change is most noticeable around Idaho's mining and timber communities. Ironically, in recent years another sort of railroad signature has become progressively more visible in places where the tracks never ran. In the forests of northern Idaho the enormous Northern Pacific land grant, dating from the 1860s, is cause for contention between industry and environmentalists over clearcuts on forest land that belonged to the railroad.

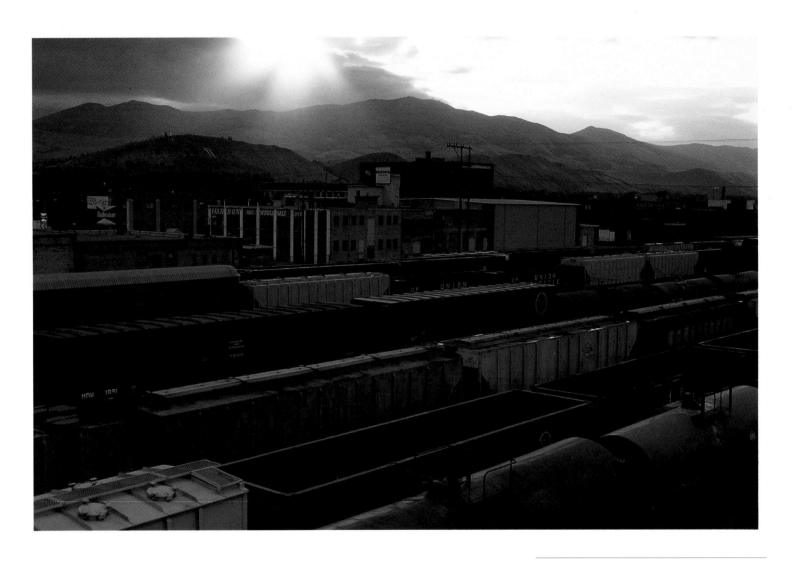

The sun rises over Pocatello's railroad landscape in September 1991. From the 1880s until America entered World War I in 1917, railroad builders extended a network of tracks across Idaho. In the process they spurred the rise of new cities and industries and effectively publicized Idaho as a promising field for investment, settlement, and tourism.

Idaho grain is shipped to market by rail from Bancroft, October 1994.

The railroad landscape at Bonners Ferry, July 1991.

An industrial landscape made possible by railroad connections: a Simplot phosphate fertilizer plant located along Union Pacific tracks west of Pocatello, September 1991.

HIGHWAY HABITATS

Railroad lines in Idaho never extended any farther north than New Meadows or farther south than Grangeville. For many years the only north-to-south link was a seasonal cattle trail that threaded its way along the eastern rim of Hells Canyon; the wild waters below thwarted any attempt to establish a steamboat alternative. Nothing changed until a rudimentary highway opened in 1919, offering the first all-weather land link between north and south.

Another obvious transportation gap existed east of Lewiston, where the Bitterroot Mountains blocked access to Montana. For years Lewiston was the end of the line for steamboats that brought passengers and freight upriver from Portland. A paved highway was completed up the Clearwater Valley and across Lolo Pass to Missoula only in 1962. U.S. Highway 12 became a funnel for thousands of truckloads of Montana and Dakota grain that poured annually into Lewiston after that city became Idaho's only seaport in 1975. That year the last of eight dams was completed to make the Snake and Columbia rivers a highway for barge traffic to Portland.

Promising to redefine the Idaho landscape in even more dramatic fashion was the new network of super-highways initiated by Congress in 1956. During the decades that followed, multi-lane interstate expressways enabled travelers to speed across the northern panhandle and Snake River plain in a few hours, times that would have been unbelievable to the pioneers. But construction of new transportation corridors seemed invariably to result in consequences never envisioned by their proponents. Interstate highways contributed to suburban sprawl in the Boise-Nampa-Caldwell metropolitan area and also attracted motorists to gas-guzzling, high-compression, high horsepower, ego-boosting automobile behemoths.

That was not all. Highway corridors themselves formed distinctive habitats. Travelers on Idaho's interstate highways, instead of being able to sample sun-ripened tomatoes or sip fresh cherry cider at a farmer's roadside stand as motorists had previously done, were confined to the pavement by endless miles of fence wire. Even at interchanges the fast-food outlets and service stations appear

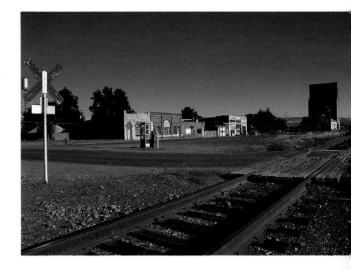

Tracks are still prominent in Midvale in August 1994. By the eve of World War I—the height of the railway era—steel rails defined major aspects of life in Idaho. Railway connections did not guarantee future prosperity or metropolitan status, but it seemed axiomatic that no place of consequence could exist beyond the sound of a locomotive whistle. Stagecoach lines extended to settlements too small to attract railway connections.

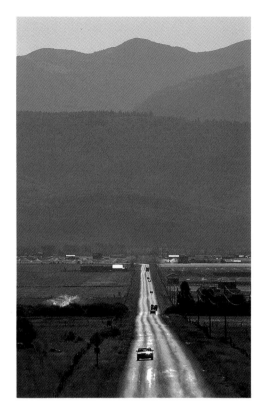

Highway 31 west of Victor, August 1994.

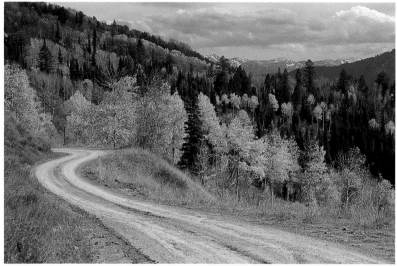

Numerous hunters used this country road east of Palisades Dam in October 1994. It wanders through a mixture of aspens and subalpine firs. Beyond the railway landscape lay the Idaho outback. For many years, to travel there meant leaving the train and hiring a horse or carriage or changing to a stagecoach. For all practical purposes that part of Idaho did not exist for most turn-of-the-century travelers.

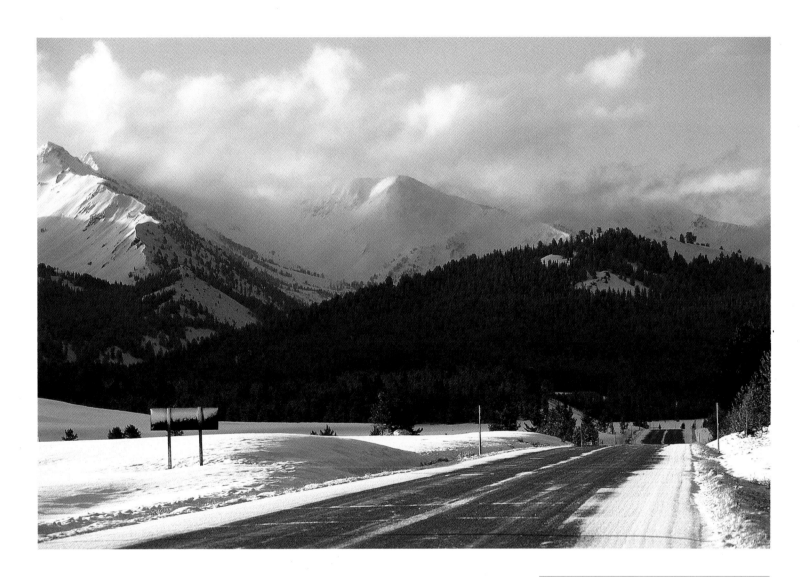

South of Stanley, Highway 75 nears the still-frozen headwaters of the Salmon River in April 1995.

to have been stamped from the same cookie cutter. John Steinbeck expressed it well in *Travels with Charley* (1961) when he prophesied—tongue in cheek, perhaps—that when the expressways were completed "It will be possible to drive from New York to California without seeing a thing." That is especially true for Interstate 84 across the Snake River plain.

Cellular phones, satellite and cable broadcasts, fax machines, and computer modems continue the historic process of speeding communication both within Idaho and with the rest of the world. Advances in electronics make these new corridors of power far less visible than the traditional highway and railroad links, yet their capacity to redefine the Gem State is evident in the newspaper headline "Booming City of Boise is no Longer the Frontier." Sophisticated new communication technologies have the power to alter spatial relationships anywhere in Idaho, even as steamboats and stagecoaches once did.

(TOP)

North Fork on Highway 93 was a popular stop on a warm August evening in 1994.

(BOTTOM)

Fresh fruit for sale along U.S. Highway 95 north of Riggins, July 1993.

LANDSCAPES OF OPPORTUNITY

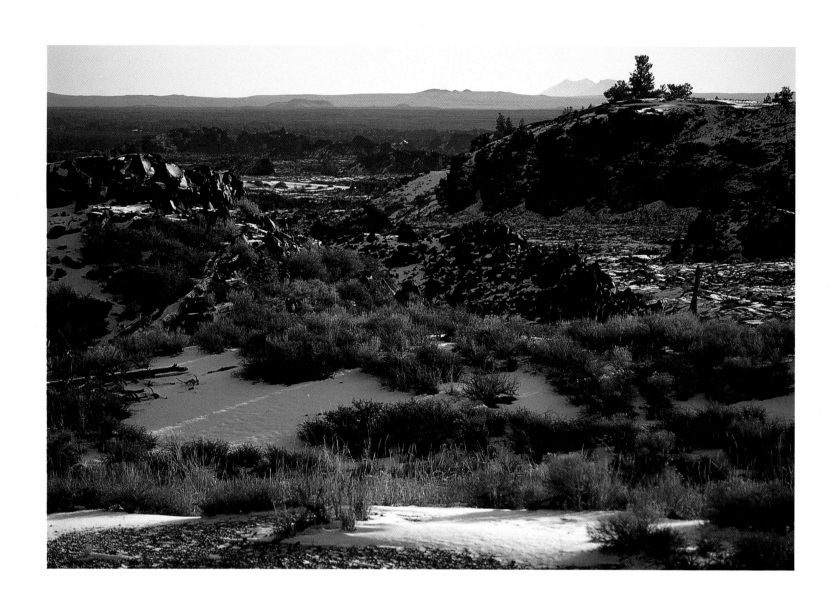

CHAPTER FOUR

LANDSCAPES OF OPPORTUNITY

IN MANY PARTS OF Idaho, Euro-American civilization had difficulty putting down roots. That was literally true along the Snake River plain, where annual rainfall was far less than twenty inches, the generally accepted minimum necessary to raise crops. There and elsewhere, much of the land was high and windswept, winters were cold and harsh, summers hot and dry, and distances between population centers overwhelming.

Along the Snake River plain the heat of summer and lack of water desiccated the once high spirits of Oregon-bound emigrants. They despised the parched and treeless land as one more obstacle on their way to Oregon's lush promised land. The only good thing they had to say about the area was that it contained fascinating geological features like Soda Springs, Thousand Springs, and Shoshone Falls.

In the 1860s the discovery of precious metals above the Clearwater River and in the Boise Basin attracted hordes of fortune seekers and merchants, stockraisers, and farmers to supply their daily needs. At about the same time, Mormon agrarians established a series of settlements in the extreme southeastern corner of Idaho. Neither group of newcomers had any compelling reason to promote

(OVERLEAF)

Sunflowers and cattails line an irrigation ditch north of Grand View, September 1990.

(OPPOSITE)

The forbidding landscape of Craters of the Moon National Monument, November 1994.

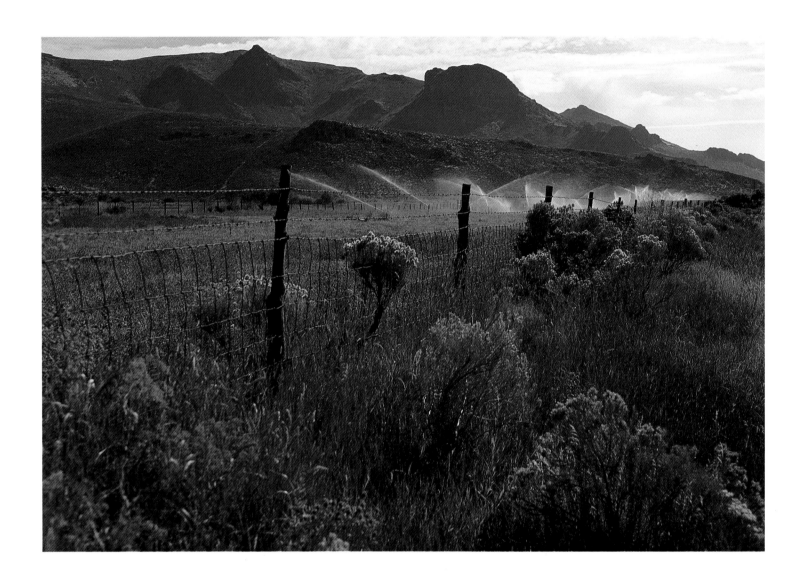

Irrigating crops near Picabo along Highway 20, September 1991.

Idaho as a desirable place for home, health, or recreation until the advent of transcontinental railroads during the 1870s and 1880s. Few Euro-Americans attempted to settle large parts of the Snake River country until the early years of the twentieth century. Twin Falls, now a major population center in southcentral Idaho, dates only from 1904, when an irrigation boom transformed the dry land.

Various maps included with the 1900 federal census reveal how these harsh conditions influenced settlement patterns in Idaho. Most obvious are the islands on the land: unlike in eastern states, where people spread across the country from the Atlantic seaboard to the Mississippi Valley to form a more or less continuous area of settlement, colonists of southern Idaho tended to cluster together around sources of water. The result was a few dozen outposts of population scattered across a nearly empty land. This peculiar pattern was less distinct in the northern panhandle, but even in Idaho's well-watered lands, settled areas still tended to resemble islands separated by miles of dense forests and uninhabited mountain ranges.

Irrigation and railroads formed the winning combination that transformed a forbidding natural landscape into one of opportunity. Railroads in the eastern United States generated freight and passenger business by serving already established population centers and markets. Western lines, by contrast, had to build across hundreds and even thousands of miles of rugged and lightly populated country and generate passenger and freight revenue by running from nowhere in particular to nowhere at all. The early railroads of Idaho had to create new towns and markets and foster settlement of countless acres of farmland by promising investors a share of future wealth, a task that sobered even the most optimistic westerner. Only the federal government had the resources necessary to underwrite the risk-takers.

To encourage construction across the northern West, a generous Uncle Sam gave the Northern Pacific Railroad a landed empire that stretched west from Minnesota across the Idaho panhandle to Puget Sound. It totaled the size of the six New England states combined. Other railroads that built across Idaho were not so fortunate, but they too had an interest in selling the area to prospective

investors, settlers, and tourists. Like the Northern Pacific, their final western destination was not Idaho, but all railroads sought to develop the country through which they passed.

Aridity and distance challenged early providers of communication and transportation as well as the skills of a generation of civil engineers, notably so along the Snake River plain where water resources were closely linked to economic prosperity and population growth. It was axiomatic that wherever railroad lines were built and water impounded and diverted to arid lands, people moved in and the price of real estate rose. Even today a large irrigation canal silently diverting water to make the desert bloom offers a graphic tribute to engineering know-how.

In movie dramatizations of the western past it is often a motley cast of sheriffs, stagecoach drivers, wagon-masters, trailhands, cowboys, badmen, and saloon molls who compete for attention. Yet the largely unsung engineers—civil, mining, electrical, aeronautical, even nuclear—were responsible for a far more dramatic transformation of the Idaho landscape than all the other types combined.

Few dissenters asked why it was necessary to transform the original landscape. Young Chief Joseph complained, "I learned then that we were but few, while the white men were many, and that we could not hold our own with them. We were like deer. They were like grizzly bears. We had a small country. Their country was large. We were contented to let things remain as the Great Spirit Chief made them. They were not; and would change the rivers and mountains if they did not suit them." Most newcomers were too busy transforming the land to reflect on such dissent from what they called progress.

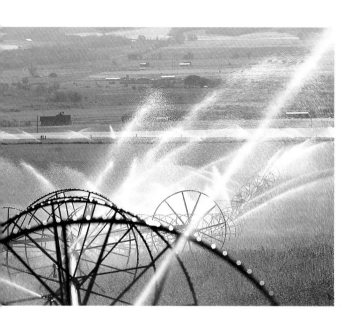

Sprinklers west of Driggs, August 1994.

WORDS OF WONDER

Transformation of the Idaho landscape was not merely a matter of finance or engineering prowess. It also involved ceaseless promotion. The wordsmith was an invaluable ally of the civil engineer and business executive. Beginning in the

Relining the New York Canal near Boise with reinforced concrete in the early twentieth century. Courtesy: Idaho State Historical Society, #61-165.14.

1870s, railroads became promoters of settlement and development no less than carriers of people and goods. In this way they shouldered the main responsibility for transforming Idaho into a landscape of opportunity.

The popular journalist Ray Stannard Baker learned the importance of railroad promotional activity when early in the twentieth century he naively suggested to

Snow and frost cover an irrigation valve south of Salmon, November 1991.

a railroad agent that his company might be interested in a land development program. "Why," responded the somewhat startled official, "the West is purely a railroad enterprise. We started it in our publicity department." The remark contained more than the usual grain of truth, thought Baker, who added that "the West was inevitable but the railroad was the instrument of its fate." In no part of Idaho was that a more apt description than along the Snake River plain where the Oregon Short Line, a Union Pacific subsidiary, joined with irrigators to invent an alluring new landscape. The Oregon Short Line issued a pamphlet for agriculturists called *Man with the Hoe in Idaho*, which illustrated how railroad tracks and irrigation canals combined to transformed an area once dismissed as only a desert.

As if to emphasize their power to redefine western landscapes, railroad companies provided guide books—commonly titled "From the Car Windows"—to identify towns, mountains, and waterways for travelers. Other pamphlets promoted Idaho as a tourist destination, field for investment, or prospective home. Railroads even paused occasionally to salute their own efforts: "While the early settlers in Idaho had a hard struggle to get people to come and help develop the resources of the country owing mainly to her isolated location, being so far from railroad and water transportation, at last the railroads came, then the people came and soon after the development of the many natural resources commenced in earnest."

That was no exaggerated claim. When the Northern Pacific line was finally opened to the Pacific Northwest in 1883, thousands of emigrants rode the trains to the new land. To populate the area along their tracks, the railroads of Idaho regularly ran homeseekers' specials and carried emigrant families and their belongings at reduced rates. They also instituted a variety of low down-payment plans to speed settlement and generate much-needed traffic.

Joining the railroads in promoting Idaho were individual boosters, real estate agents, newspaper editors, private immigration societies, chambers of commerce (often called commercial clubs), and various "improvement companies." Their promotional activities would seek to create new and desirable landscapes to lure tourists, but especially settlers and investors, in order to promote eco-

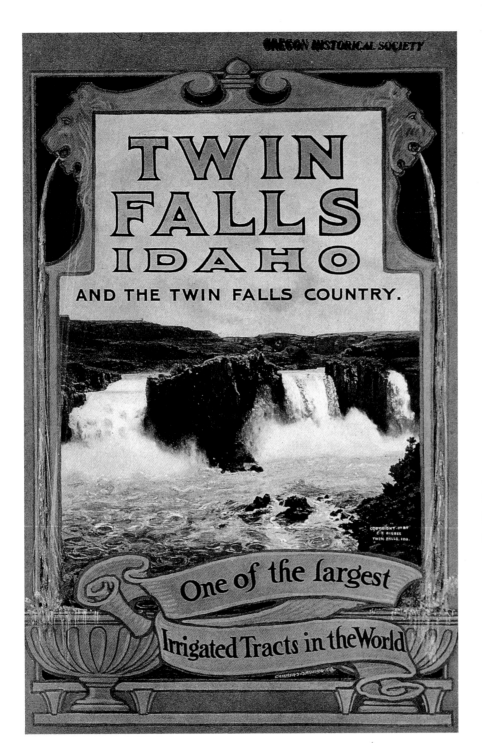

The front cover from a railroad promotional brochure for Twin Falls in the early twentieth century. Courtesy: Oregon Historical Society.

nomic growth and guarantee a prosperous future. Boosters essentially applied consumerism to the Idaho landscape. In the early twentieth century, timber companies became promoters in order to sell their logged-off lands to agriculturists. Advertising, incidentally, was not limited to printed materials. It also took the form of oratory and elaborate displays at fairs and expositions, including the great national ones held in Philadelphia in 1876 and Chicago in 1893.

Just how many settlers the various promotional pamphlets and exhibits attracted to Idaho will never be known. Tens of thousands, perhaps even millions, of people scanned railroad brochures and broadsides that promoted settlement of Idaho and the West. "Ask any settler in some part of the West why he immigrated," observed Ray Stannard Baker in 1908, "and he will invariably point you back to the beguiling road, a pamphlet, a fevered folder, an enthusiastic agent."

A Northern Pacific brochure promoted irrigated farming in the Lewiston area in the early twentieth century. Railroads probably left their longest lasting imprint on Idaho as a result of their century-long effort to advertise the state to prospective tourists and settlers. Over the years railroad publicists devoted enormous effort and skill to repackaging the landscape, and in that way they created enduring popular images of the Gem State. Railroads became transmitters of visual information to those who knew little or nothing about Idaho. Courtesy: Special Collections, University of Idaho Library, HC 108 L4N6.

TOURIST WONDERLANDS

Over the years, dozens of different brochures promoted settlement and economic development of Idaho, but most of the early ones seldom mentioned tourism. Among the first to call tourist attention to Shoshone Falls, Payette Lakes, the mineral waters of Soda Springs, and other natural wonders of southern Idaho was *To the Rockies and Beyond* (published in various editions between 1878 and 1881). Railroad tourism, like development activity in general, meant transforming landscapes widely considered unappealing into veritable wonderlands.

When Oregon Short Line tracks reached the Wood River Valley in the early 1880s, Hailey Hot Springs became Idaho's first real summer resort. Guyer Hot Springs, two miles by stage from nearby Ketchum, had waters that were "good for all nervous complaints, rheumatism, skin and blood affectations. This place is much resorted to by tourists and invalids. It is a beautiful, quiet mountain retreat." Highland House on the north shore of Lake Pend Oreille provided a destination for tourists on the Northern Pacific line.

Coeur d'Alene emerged in the early twentieth century as a popular summer

The Oregon Short Line issued this attractive brochure boosting Buhl in the early twentieth century. As printing technology evolved, so too did the sophistication of promotional efforts. The early twentieth century was probably the golden age in terms of a remarkable outpouring of railroad promotional literature devoted to landscapes of opportunity in Idaho. Attractive pamphlets were devoted to places as diverse as Weiser, Boise, Gooding, Richfield, Hailey, Burley, Rupert, Twin Falls, Buhl, American Falls, Pocatello, Montpelier, Blackfoot, Idaho Falls, and St. Anthony. No slums, industrial ghettos, or scenes of poverty ever appeared among the numerous photographs used to illustrate the pamphlets. There was nothing to mar their consistently upbeat tone. Courtesy: Oregon Historical Society.

Vacationing on the rivers and lakes of Idaho is the subject of this evocative brochure cover. The Gem State would not become a popular tourist destination until the northern transcontinental railroads made the trip easy. It was only after completion of the Northern Pacific line across the panhandle in 1883 and the Oregon Short Line across southern Idaho a year later that boosters found it practicable to lure tourists along with homeseekers and investors. Even after through passenger trains crossed Idaho, most tourists from the East preferred to go to California and Colorado because of the extra time and money required to travel to the far Northwest. Nonetheless, as early as 1886 the Union Pacific Railway issued a booklet called Inter-Mountain Resorts which called attention to Salt Lake City, Ogden Hot Springs, Yellowstone National Park, and three southern Idaho destinations: Soda Springs, Shoshone Falls, and Guyer Hot Springs. Looking at curiosities of nature and the search for better health were two of the driving forces behind Idaho tourism in the late nineteenth century. Courtesy: Eastern Washington State Historical Society.

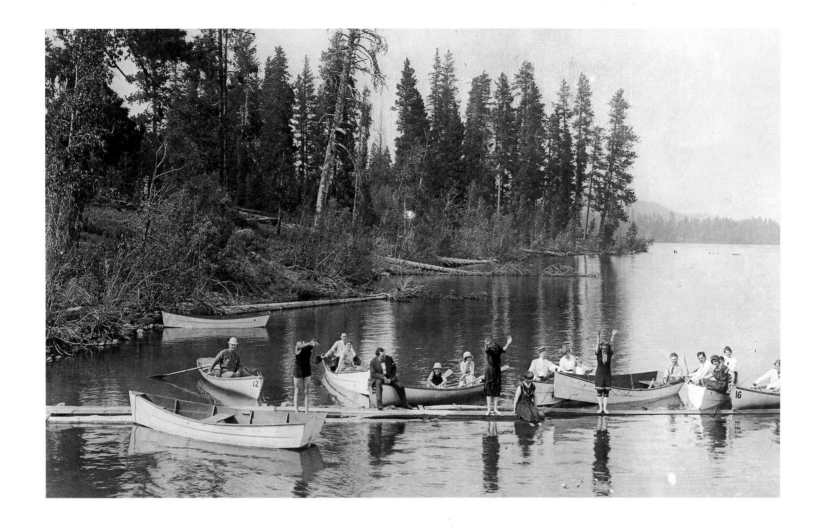

Wesley Andrews photographed boaters and bathers on Payette Lake around the time of World War I. Courtesy: Oregon Historical Society, #ORHI 33874.

destination when an electric railway from Spokane was connected with steamboats for a trip across the lake and up the "shadowy" St. Joe River, an excursion of some two hundred miles. A short distance north of Coeur d'Alene, on the shore of Hayden Lake, the same electric railway company built one of the finest resort complexes in Idaho. To implement its grand design for a "Green City in the Pines," the company hired the noted landscape architect J. C. Olmsted of Brookline, Massachusetts, son of the designer of New York's Central Park, to plan the 158-acre grounds. The resort's centerpiece was Bozanta Tavern, a Swiss chalet-style building designed by Spokane architect Kirtland Cutter. Bozanta

Tavern featured a wide veranda looking over the lake, which "has always been noted for its big, gamy cut-throat trout and bass." The Hayden Lake resort also featured a golf course, four tennis courts, boating and bathing facilities, and a mountain trail for climbers. When the original golf course was expanded from nine to eighteen holes in 1912, it became the largest in Idaho.

Boosters also transformed the once forbidding Snake River plain into a tourist destination in the late nineteenth century, with the most notable attraction being Shoshone Falls. The site suffered from the handicap of isolation, but promoters used the anti-urban prejudice then common in America to transform the remoteness into an asset. "Shoshone differs from every other waterfall in this or the old country. It is its lonely grandeur that impresses one so deeply; all of the other historic places have the adjuncts of civilization, and one is almost overshadowed by a city while in their presence."

Selling Idaho's great outdoors grew even more important as the twentieth century progressed. This was especially true when mills and mines shut down in several natural-resource oriented communities which then turn to tourism for their survival. Coeur d'Alene, Wallace, McCall, and Ketchum are all examples of one-time timber or mining towns that emerged as tourist centers. Because tourism is likely to loom large in the Idaho economy of the future, landscapes will continue to be redesigned to be appealing both to visitors and settlers. In its various incarnations the landscape of opportunity will continue to define the Gem State for years to come.

Warm Springs Lodge and the ski slopes of the Sun Valley-Ketchum area, April 1994.

CONTESTED TERRAIN

EXAMPLES OF CONTESTED terrain exist all over Idaho today, although some of these places remain more invisible to an onlooker who lacks a sense of the past than do other defining landscapes. In other instances contested terrains appear as striking as the 1995 newspaper headline that warned, "Idaho Serves Notice: Nuclear Battle Looms," a reference not to thermonuclear war but to the controversy over shipment of atomic waste to the Gem State for storage.

The land destined to become Idaho was contested terrain even when it was still populated mainly by Native Americans. As the missionary Samuel Parker observed in the early 1830s: "After some time spent in reflections and solemn mourning, we left the place and proceeded down the [Salmon] river, and encamped near Bonneville's Fort, which he has abandoned and which is situated in a small pleasant vale. This place would be favourable for fur business, was it not that it is on ground where conflicting tribes often meet."

Potential for conflicts of various types increased during the 1860s as a result of Idaho's peculiar pattern of settlement. During two previous decades, Oregon-bound colonists had hastened to leave the Snake River plain in their

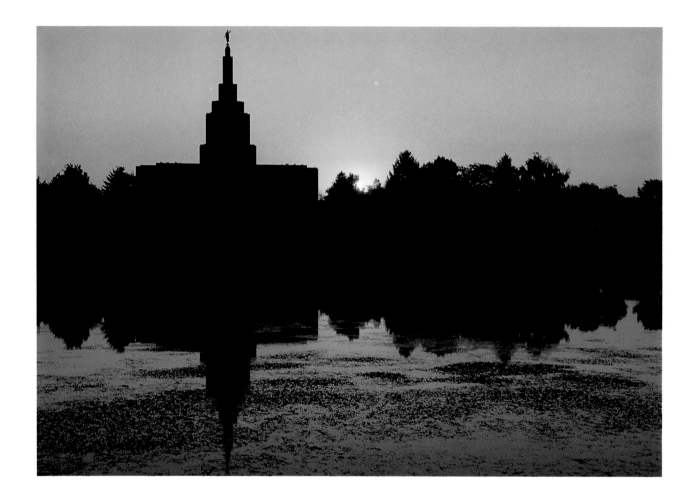

The sun rises behind the Mormon Temple on the east bank of the Snake River in Idaho Falls, September 1991.

dusty wake. Aversion to settlement changed only in 1860 when a stream of people, composed mainly of agrarians who were members of the Church of Jesus Christ of Latter-day Saints, headed resolutely north from Salt Lake City to establish a series of Mormon outposts. Thirteen colonists established Franklin, Idaho's oldest town, although only in 1871 when the boundary was properly surveyed did they realize they had left Utah.

A year after Franklin was settled, fortune-seekers poured into the valleys and uplands of the Clearwater and Salmon rivers east and south of present-day

Lewiston in search of gold. Many of them continued farther south in 1862 to establish the first mining camps in the Boise Basin in the mountains northeast of present-day Boise. These miners always worked at a feverish pace. They were participants in a gigantic lottery, and none could predict who would find the elusive pockets of gold that would make a poor man wealthy. Their recreation was often rough and consisted mainly of gambling, drinking, dancing, and theatricals.

By contrast, the lives of Franklin's Mormon pioneers were measured and orderly. First they carefully surveyed the townsite, then dug a ditch for water and planted their gardens and fields. This marked the birth of agriculture in southeastern Idaho. The Mormon leader Brigham Young visited the village and pronounced it good. Young also named several of Idaho's new Mormon settlements: Montpelier (to honor the capital of his native Vermont), Ovid, Bennington, Bloomington, St. Charles, and Fish Haven.

All of these places developed in a similar fashion, consistent with a highly organized society. These self-contained Mormon settlements centered on family and religion and could be identified by their wide streets, landmark tabernacles and other church structures, and general air of prosperity. Homesteads clustered closely about the church, with fields on the outskirts. Faith, morals, crops, and irrigation were all matters of community concern. The contrast between pietistic and orderly agrarian Mormon towns and rough-and-tumble mining camps was stark. It seemed to symbolize a religious and cultural as well as geographic division that that made Idaho Territory a contested terrain for several decades.

Nowhere else in the United States did Mormon and non-Mormon populations divide as sharply as they did in Idaho, and therein lay the seeds of an anti-Mormon crusade. The Mormon sense of group solidarity as reflected in their settlement pattern and their religious and dietary customs caused outsiders, or "Gentiles," to regard them with suspicion. Being a "peculiar people," a Biblical term the Latter-day Saints applied to themselves, inevitably seemed to breed persecution. Some "Gentiles" considered Mormon devotion to church to be un-American, while others undoubtedly coveted the fertile Mormon farmsteads.

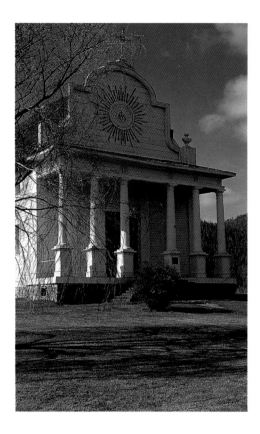

The Catholic mission for Coeur d'Alene Indians at Cataldo, photographed in 1972, is Idaho's oldest standing building. Primarily in the 1830s and 1840s, Catholic and Protestant missionaries regarded the northern Rocky Mountains as contested terrain in their quest to convert Native Americans.

Above all, however, it was the belief that males had the right to marry more than one wife, a practice referred to as polygamy, that made Mormons convenient targets for hostile non-Mormons. In fact, probably no more than three percent of Idaho's Mormons actually engaged in plural marriage, but when Congress passed the Edmunds Act in 1882, which barred polygamists from voting, holding office, or serving as jurors in cases involving plural marriage, it handed opponents a powerful weapon to use against Mormons.

In May 1886, in a typical scenario, Idaho's federal marshal went armed with one hundred forty warrants to arrest suspected polygamists but was able to apprehend only twenty. Mormons developed an effective early warning system that permitted most polygamous men to remain with their families. Few successful raids could be made in Paris, Idaho, for instance, because law-enforcement officers who got off the train at Montpelier invariably attracted public attention by their efforts to hire transportation for the last ten miles of the journey there. Even if lawmen managed to elude spotters in Montpelier, two watchmen stationed at each end of Paris formed a second line of defense. They sounded an alarm on tin horns, enabling polygamists to go into hiding in secret passages in their homes or escape to nearby fields where the ground cover was deliberately kept high.

Idaho's 1890 state constitution went so far as to deny Mormons even the right to vote. A few months later the church's president, Wilford Woodruff, urged all Latter-day Saints to comply with civil laws regarding marriage, and the state gradually relaxed its restrictions. Nonetheless, the fact that most Mormon settlement in Idaho today is still concentrated in the southern part of the state contributes to sectional distinctiveness that separates the Gem State culturally and politically.

Division of early Idaho between Union and Confederate factions during and after the American Civil War further complicated matters. In many ways, Idaho during the mid-1860s was as much Confederate as Union territory. Its remote location coupled with the appeal of mining camp bonanzas made it a haven for people on both sides who sought to escape the horrors of war. Their differences made for lively public discussions and flag-waving demonstrations that led to occasional

brawls in the barrooms and dusty streets of Idaho's many mining communities. In the Idaho legislature a large contingent of pro-Confederate lawmakers battled for their cause.

Nineteenth century Idaho also suffered serious violence as a result of deep divisions between Native Americans and newcomers during the 1860s and 1870s. The tragic flight of young Chief Joseph and his Nez Perce band in 1877 is perhaps the best known of these conflicts, but far more vicious was the Battle of Bear River in southeastern Idaho in 1863. In that conflict, Colonel Patrick E. Connor and California volunteers sent to protect settlers at Franklin virtually annihilated a band of Shoshone men, women, and children. In this wild struggle, the California volunteers suffered twenty-two deaths, while Connor's official tally listed two hundred twenty-four Indian casualties (although Utah citizens who visited the battlefield the next day counted three hundred sixty-eight slain Indians, including almost ninety women and children). The Battle of Bear River ranks as one of the worst slaughters of Indians in the American West. Idaho's Indian wars did not end until 1879.

But the years of trouble were far from over. During the 1880s conflicts arose between whites and Chinese, who at one time comprised about one-quarter of Idaho's population. The belief that Chinese miners had hoarded great quantities of gold through their hard work and frugality led to one of the most vicious massacres in Idaho history. The site was north of Hells Canyon, the year was 1887, and robbery was the probable motive. In that incident a "gang of cowboys" shot or hacked to death thirty-one Chinese miners. The victims were also tortured in an apparent attempt to learn where they had hidden their supposed cache of gold.

Still another type of conflict broke out in the Coeur d'Alene mining district in 1892 and again in 1899 where miners battled against mine owners. The stubborn violence required intervention by federal and state troops. The presence of soldiers on the streets of Wallace and Kellogg left no doubt that this was contested terrain. This bitter conflict further resulted in the assassination of former Idaho governor Frank Steunenberg at his home in Caldwell in late 1905.

Adding to early Idaho's deep divisions over race and economics were the usual

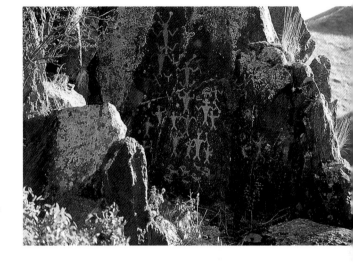

Native American rock art along the Snake River south of Lewiston, October 1993.

problems caused by poor communication and transportation, lax to nonexistent local law enforcement, and an always underfunded and often poorly administered government. Even after Congress shrank Idaho to its present dimensions in 1868, the territory remained divided against itself.

Although conflicts during the tumultuous nineteenth century would require a long time to forget, the attention of Idahoans after 1900 was fixed less often on violence (with exception of the Steunenberg murder and the sensational trials that followed). More frequently, Idahoans focused on the new-found prosperity coming from the irrigation boom that transformed southern Idaho from desert to agricultural empire during the first two decades of the new century. During that time a whole new Idaho arose from the sagebrush plain as a result of life-sustaining water supplied by private and federal irrigation projects.

New towns and cities were built, most notably Twin Falls, and in 1915 Idahoans took pride in the completion of the world's tallest dam, Arrowrock Dam, which impounded water to irrigate many new farms. It was a measure of Idaho's new-found confidence that between 1900 and 1919 the number of counties in the state doubled. During that time the numbers of acres of farmland and miles of railway lines also increased dramatically, and the population of the Gem State grew from 161,772 in 1900 to 431,866 in 1920. But even with its transformation into a modern state during the first two decades of twentieth century, the Gem State did not cast aside all forms of contested terrain along with its disorderly frontier past.

TOWN AND COUNTRY/MONEY AND AESTHETICS

Contemporary Idaho's number one source of income is agriculture, followed by manufacturing, tourism, lumber, and mining in that order. Each basic economic activity created a characteristic landscape which, as a result of profound technological and economic changes, possessed the potential to become a new example of contested terrain—perhaps none more so than agriculture. Here was a landscape shaped and reshaped by competing technologies, economic interests, markets, and value systems.

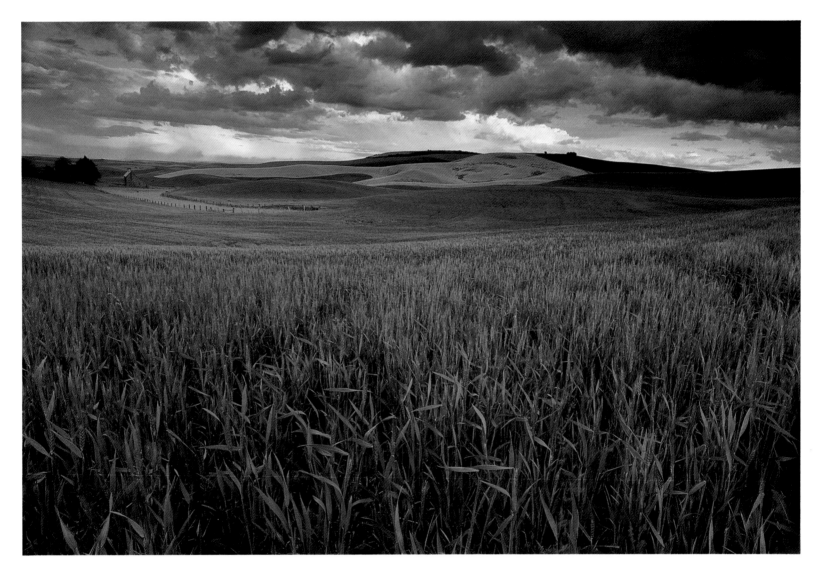

Spring storms bring needed moisture to fields of wheat and barley surrounding Moscow, June 1994.

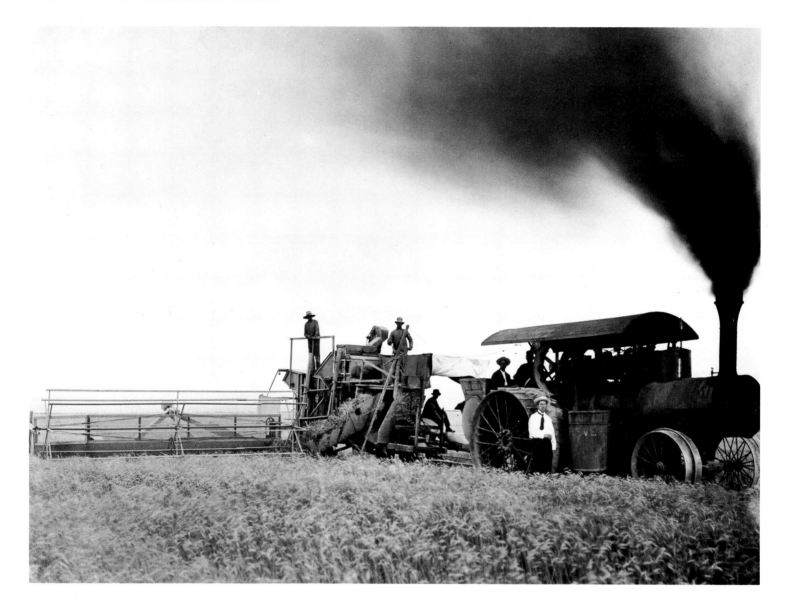

A steam tractor dominates a harvest scene near American Falls in 1914. Courtesy: Idaho State Historical Society, #1958.0004.

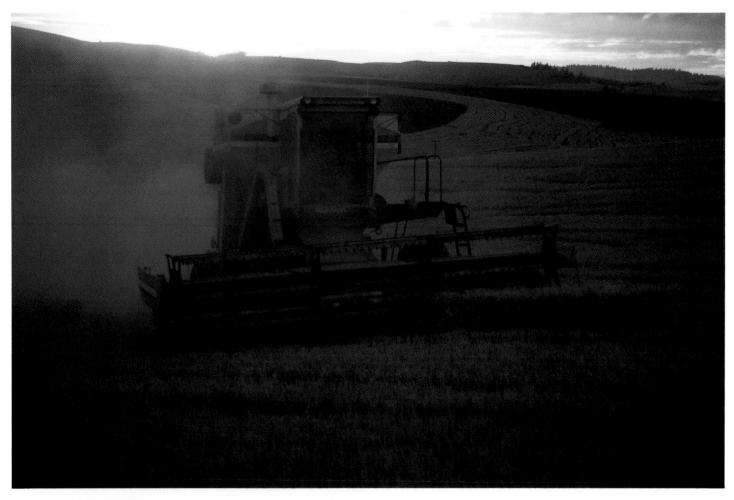

Idaho agricultural areas, for example, experienced profound demographic changes during the half-century after World War II, and these were reflected in the landscape. During the 1950s alone at least seven thousand Idahoans left the farm for the allurements of the city. Rural land holdings were reconfigured. The number of acres of farmland actually increased slightly, mainly as a result of newly irrigated tracts, and so too did the average size of farms. But one change had clear implications for the future: during the 1950s the number of Idahoans living in urban areas increased by twenty percent, while the number in rural areas increased by only four percent.

Technological change: darkness overtakes a modern combine harvesting wheat on the Howard Jones ranch near Genesee in August 1989.

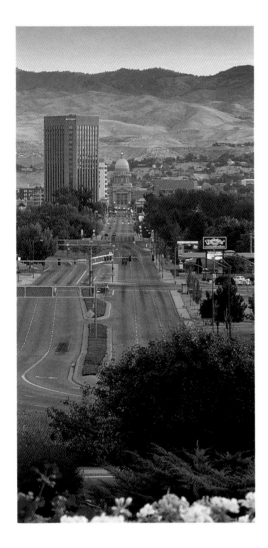

New high-rise buildings dwarf the state capitol in downtown Boise, April 1995.

Eventually Idaho cities spilled out across the adjacent countryside. New dwellings were often little more than plain, little boxes ("ticky-tacky houses"), but a home in a suburban landscape was never a matter of mere shelter. For their proud owners they represented a step up from the apartments, dormitories, or military barracks of earlier years.

Suburban sprawl onto nearby farmlands is most noticeable in recent years in the Boise-Nampa-Caldwell area, but no less dramatic in places as widely scattered as Coeur d'Alene, Pocatello, and Idaho Falls. Just north of my Moscow home is a large tract of land that only a year or two ago was a rolling field of wheat. Now it is divided into crowded city streets, boxy apartments, and condominium blocks, all without any redeeming aesthetic value. The same thing will likely occur in the near future to spoil my pastoral view to the south.

Similarly, the arterial highways leading to suburbia lack beauty because they invariably became magnets for a jumbled array of used car lots, drive-in restaurants, real estate offices, and dry cleaners. Like many suburban developments, the main roads form contested terrain between monetary and aesthetic values, and in this face-off money traditionally wins.

Idaho's central cities are by no means dead. The soaring skyline of downtown Boise today attests to the economic growth taking place there in a broad array of businesses, including several new high-tech firms. Yet Boise remains an oasis in many ways. Not only is it a city of trees on an arid plain, but thirty years ago it was described as the only city in the nation that was more than three hundred miles from another city. That is still true in the 1990s, when in America's so-called "outback" or "empty quarter" states of Idaho, Montana, Wyoming, North Dakota, and South Dakota, only Boise and Sioux Falls had a hundred thousand or more residents.

Boise and other parts of urban Idaho became contested terrain of yet another sort during the first half of the 1990s as a result of rapid population growth. Already resident taxpayers resented having to fund enlarged budgets for health and welfare, fire and police protection, and an expanding infrastructure of roads and schools even before new residents were added to the tax rolls. These upfront costs, plus construction of palatial new homes built with California dollars caused property tax rates to soar, and this fueled tax protests.

Rapid growth fostered contested terrain in terms of more than just property taxes. Coeur d'Alene residents feared that affluent newcomers would destroy the city's old ambiance by erecting high-rise buildings along the scenic waterfront. Residents of other locations were also concerned with how to treat the natural landscape in the response to rising population.

An evocative example of Idaho's historic built environment is the Idanha Hotel in Boise, pictured here in April 1995. It opened in 1901 and is on the National Register of Historic Places. In 1995 the Maharishi Vedic University of Idaho bought the building.

Growing interest in protecting natural landscapes for aesthetic reasons reflects a profound change of attitude in the Gem State. In the 1880s and 1890s the main question facing Idahoans was how to develop nature's abundance. Few disputed this priority. Even a century later, many people still see development of natural resources as the key to Idaho's future prosperity. Now, however, a rising chorus of dissenters wonders aloud whether the state needs another dam or a nuclear waste-processing facility if it means degradation of the Idaho environment.

During the 1960s and especially the 1970s the environment became a key public issue for the first time as Idahoans debated questions of air and water pollution and whether to dam scenic Hells Canyon. An increasing number of people realized that nature's beneficence, perhaps more than anything else, defined the character of modern Idaho, and many controversies ostensibly about the environment were in reality debates about the future of the Gem State. As nothing else could, the ongoing discussion made clearly visible the impact of politics and government on the landscape.

Regardless of individual political persuasion, most Idahoans have faith in the political process, a fact evidenced by one of the top rates of voter turnout in the nation. Public officials thus play a major role in resolving the seemingly inevitable conflict between metropolitan dwellers, who regard non-agricultural portions of the Idaho backcountry as recreational getaways, and those who wish to develop those areas for their natural resources. Should lands—which could be set aside as a wilderness heritage for future generations of Idahoans— be used up to create logging or mining jobs, even if those future Idahoans are more likely to spend their working lives in offices than in the fields, forests, or mines?

Idaho's landscapes of economic change and environmental concern often represent opposite sides of the same coin. With the Gem State attracting an increasing number of residents because of its natural setting rather than because of jobs in timber, mining, or agriculture, more contested terrain will likely arise as those recreationalists clash with Idahoans who continue to view land mainly in terms of resource extraction.

Sawtooth Mountains scenery for sale near Stanley, April 1995.

LANDSCAPES OF ENVIRONMENTAL CONCERN

Since World War II Idaho's list of contested terrain involving the environment has become quite long. Some controversies center on dams and water resources, others involve scenic backcountry like the White Clouds Peak area, and still others are about pollution—nuclear waste stored at the Idaho National Engineering Laboratory and heavy metals and acid rain in the Coeur d'Alene River valley. But perhaps the single most divisive issue is what to do with the Gem State's magnificent expanse of wilderness lands. Idaho has more Congressionally designated wilderness land than all but one or two other states apart from Alaska, a total of approximately four million acres including the 2.3 million acre Frank Church River of No Return Wilderness created in 1980.

The National Reactor Testing Station near Arco, May 23, 1962. Courtesy: Idaho State Historical Society, #72-205.22.

Setting aside state and federal land as parks and recreation areas was often justified in economic terms such as that the land was worthless with respect to minerals and timber, or conversely that the action was a way to generate tourist dollars. But what about wilderness lands? The issue was often cast in terms of whether it was better to log or mine the backcountry for the sake of jobs and profits or to preserve the region's remaining wilderness areas for their own special qualities. Critics charge that "locking up" so much land was elitist and economically indefensible. Environmentalists respond that the nation needs wild country even if most people only drive to the edge for a quick look, that it is wilderness land that gives Idaho the sense of empty space so essential to any definition of the Idaho character.

Probably nowhere in Idaho did the concept of contested terrain acquire more meaning than a sparsely populated portion of the Snake River plain west of Idaho Falls where Cold War tensions radically altered the natural landscape. That is the

location of the largest permanent federal installation in Idaho, a sprawling nuclear reservation that dates from March 20, 1949 when the Atomic Energy Commission announced plans to located a special reactor testing facility on the site. By combining grounds formerly used to test naval ordnance with thousands more acres of desert land the Atomic Energy Commission created a reservation totaling 870 square miles, or about three-quarters of the land area of Rhode Island. Here the federal government invested millions of dollars to build fifty-two reactors, most of them one of a kind test facilities that were subsequently phased out.

In the early years the facility's scientists considered plans for nuclear powered railway locomotives and aircraft; now they engage in research projects involving electric vehicles, lasers, and biotechnology. Today, however, Idahoans do not all view the atom as a friend, and some fear the site produces and stores wastes that will permanently foul the Snake River aquifer.

Concerns about pollution are not unfounded. Government documents reveal that between 1957 and 1963 there were intentional atmospheric leaks of radioactive gas. The radiation, as measured in curies, was four thousand times greater than the amount released during the infamous Three Mile Island accident in Pennsylvania in 1979. Already a one hundred forty acre landfill is home to seventy-five percent of all buried transuranic waste in the United States. Various isotopes of plutonium, a deadly manmade element, have been detected about one hundred feet below the ground at one storage site.

Other kinds of pollution are also at issue. For decades the south fork of the Coeur d'Alene River transported a dangerous load of zinc, cadmium, and lead from numerous mine tailings to the muddy bottom of seemingly pristine Lake Coeur d'Alene. The lead level in the Coeur d'Alene River delta in the mid-1980s ranged from one thousand to eight thousand parts per million; a normal range was fifteen to twenty parts per million background count. This was perhaps the highest lead level recorded in the United States. As early as 1932 an investigator had recommended construction of settling ponds to deal with the problem, but not until 1968, when mining firms were subjected to heavy pressure from state and federal government, did they take that step.

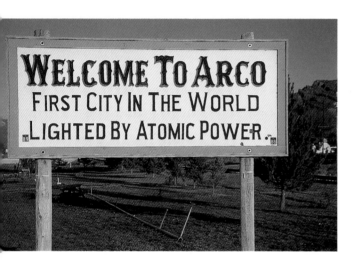

Welcome to Arco, November 1991. On the same day I took this picture, I saw a sign at the border of neighboring Blaine County that proclaimed it a "Nuclear Free County." The juxtaposition of these opposing views of the atom typifies popular attitudes in the Gem State today.

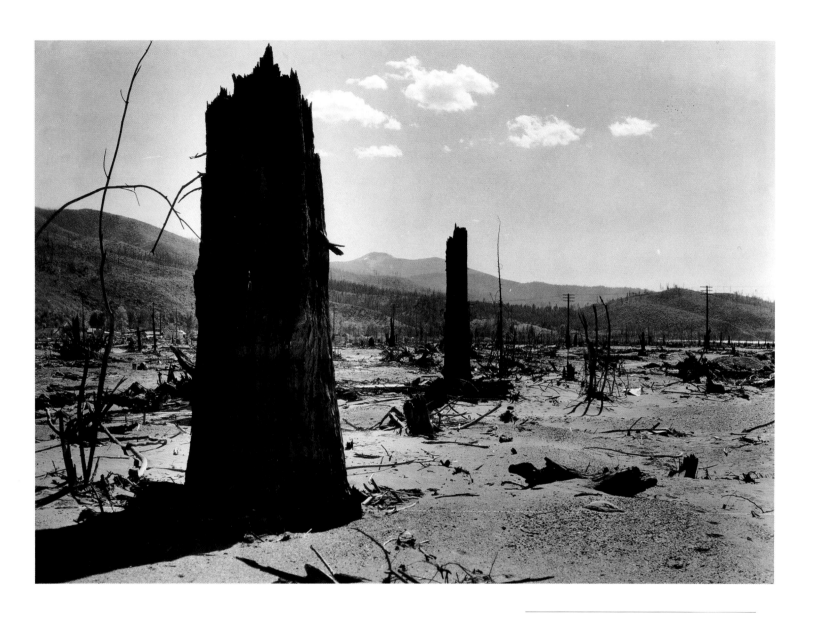

Effects of pollution from mines and smelters in the Coeur d'Alene River valley in the 1930s. Courtesy: National Agricultural Library, #28110.

(TOP)

The poisoned landscape of Smelterville, October 1992.

(BOTTOM)

Finlandia Estates is a land development project east of Donnelly. I photographed this sign in October 1994. The name derives from the large number of Finns who once settled the valley. Most ethnic landscapes in Idaho are not highly visible, and evolution from working farms and ranches to vacation ranchettes will make this one even less so.

Even with all the growth of recent years, the population landscape of the Gem State remains

No less controversial was the smelter-polluted air that hung above the Silver Valley until the early 1980s. It resulted in the highest levels of sulfur dioxide gas recorded in the United States. As acid rain, the smelter effluents were responsible for denuding the surrounding hillsides. Schoolchildren in Kellogg, where the massive Bunker Hill smelter was located, recorded abnormally high levels of lead in their blood. Toxic residues so contaminated the Silver Valley that the Environmental Protection Agency placed it on a list of hazardous sites to be cleaned up by federal money.

Still farther north, mining, metal-processing, and pulp mill wastes from Montana increasingly fouled the waters of the Clark Fork, a river which flows into Lake Pend Oreille. Cleanup will necessarily require cooperation between the two states or federal intervention. The impact on timber and mining jobs of efforts to save endangered species by mandating changes in the way Idahoans care for water and land resources further complicates matters.

There is, however, reason for optimism as the Gem State ponders its future. The wonder is not that contemporary Idaho contains numerous tracts of contested terrain. It is that Idahoans have managed to overcome their differences of years past and get along reasonably well today. This is perhaps why several landscapes that were once vivid examples of contested terrain are so difficult to recognize as such now.

unusual for the United States. It is the "whitest" state west of the Mississippi River and predominantly northern and western European in ancestry. The 1990 census recorded only about three thousand African Americans, nine thousand Asian Americans, and twelve thousand American Indians living in Idaho. Approximately fifty-three thousand Hispanic Americans constitute the Gem State's largest minority group. An increasing number of signs in Spanish, celebrations of holidays like Cinco de Mayo, and advertisements for ethnic foods point to an expanding Hispanic presence, especially in southern Idaho.

HARD PLACES

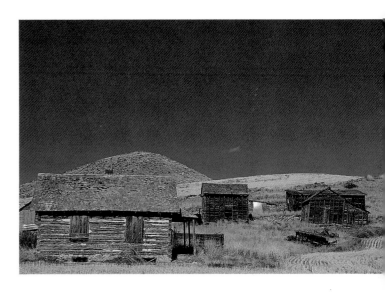

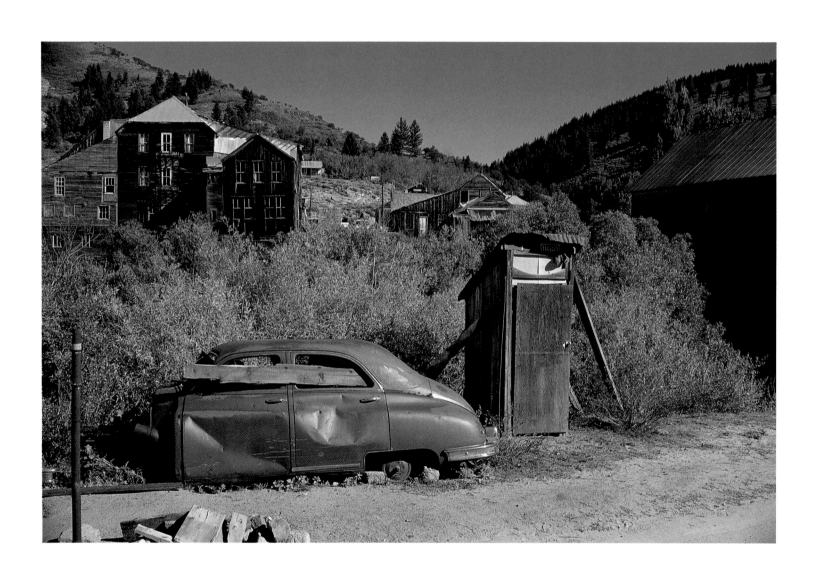

CHAPTER SIX HARD PLACES

THIS IS A CAUTIONARY CHAPTER. It should provide a sobering reminder whenever Idahoans become so dazzled by prosperity and growth that we forget the lesson of prudence taught by the Gem State's ubiquitous landscape of hard places. If we can ponder Idaho's future in the expanding urban panoramas of metropolitan Boise and Coeur d'Alene, we would do well also to consider the "other Idaho" visible in a place like Potlatch, where today even the sawmill has vanished from the landscape of this one-time timber town. The same is true for Elk River and numerous other former outposts of the timber frontier. Thus even as Idahoans look to their economic future, whether it is based on high technology or tourism or markets along the Pacific Rim, we cannot ignore the persistent problem of economic instability in extractive industries that may result in creation of still more hard places. Ruins of various types remind us that change is inevitable with the passage of time.

(OVERLEAF)

An abandoned farm near Holbrook in the Arbon Valley, October 1994.

(OPPOSITE)

A landscape of decrepitude at Silver City, September 1990. Silver City is a ghost town if the term can be applied to any community that is only a shadow of its former self.

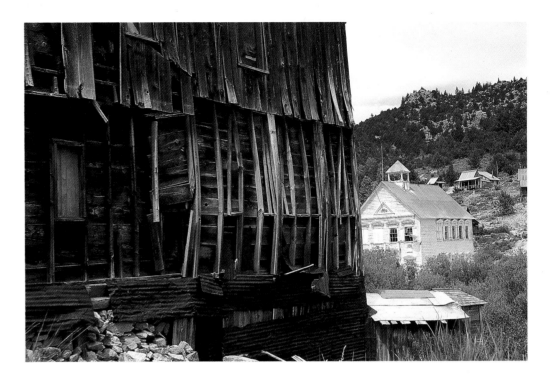

Weathered siding in Silver City, June 1992. This is probably the best ghost-town landscape in Idaho.

(OPPOSITE)

Sitting abandoned and forlorn in the empty countryside west of Highway 28 were some of the remaining buildings of Gilmore in July 1992. The sagebrush at this high elevation is much smaller than the variety that grows along the Snake River plain, which can top six feet.

I suspect that it is a rare Idahoan who has

The landscape of hard places takes many forms, not all of which result from depleted natural resources. Little remains of what was once the largest inland naval base in the world. After the Farragut Naval facility opened in August 1942 near Sandpoint it had the capacity to handle thirty thousand recruits at a time in its six self-contained training camps. Almost eight hundred buildings were constructed, including a grade school for children of civilian employees and dormitories for single women. In fifteen months, Farragut trained nearly three hundred thousand sailors. But when World War II ended, Camp Farragut closed permanently. During the immediate post-war years a part of the former base functioned for a time as Farragut College and Technical Institute. Eventually, however, forests and fields reclaimed most of the area that is now Farragut State Park.

What happened to Farragut, which was for a time the Gem State's largest population center, is a particularly vivid example of how quickly Idaho commu-

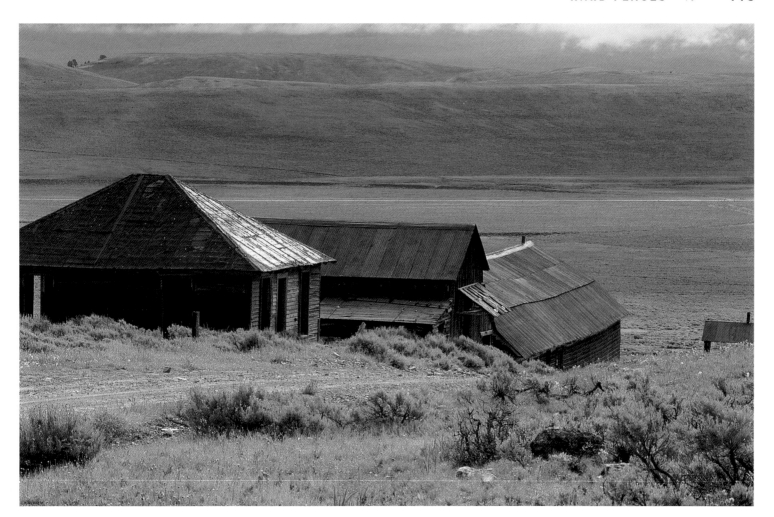

nities can rise and disappear. Even so, Farragut as a state park landscape fared better than many one-time centers of population that are now only derelict landscapes where the built environment exhibits various stages of decay. In the words of one historical geographer, they are "hard places."

The main forces that create hard places, such as boom-and-bust economic cycles, were present during the earliest days of Idaho Territory, and continue to the present day. On occasion a hard place will originate as contested terrain, but the

not taken time to visit at least one of the state's many ghost towns. But apart from satisfying our personal curiosity, have we really reflected on the economic lessons the landscape of a ghost town teaches us?

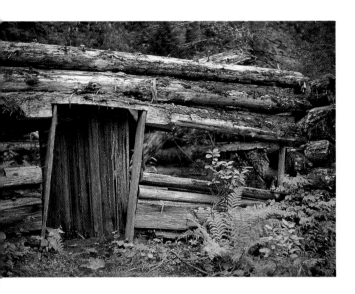

Remnants of a logging camp on Marble Creek east of Saint Maries, September 1986.

two are nonetheless different landscapes. During the last decade of the twentieth century, for example, Idaho displayed yet another form of contested terrain in the growing economic disparity between have and have-not counties.

The Boise (Ada County) area experienced unprecedented prosperity in the early 1990s, yet at that time almost half the state's forty-four counties declined in economic value. Counties dependent on the old natural resource-based economy—mining, commercial farming, and logging—were clearly not prospering in the same way as counties benefited by the high-tech industries that clustered in the Boise-Nampa-Caldwell area. Thus while some of Idaho's urban landscapes have been reshaped by rapid economic growth, others show the scars of long-term economic decline that can result in creation of still more hard places.

In no industries were the boom-and-bust cycles wilder than in timber and mining. As a result of the economic downturn of the late 1970s and early 1980s, abandoned sawmills and closed mines became increasingly common features of the Idaho landscape. Decline was visible in numerous Idaho communities which once depended for their economic well-being on the production of metal, timber, or agricultural commodities.

BOOM AND BUST

Gold! That single word lured thousands of fortune seekers into the remotest parts of Idaho. It all began on August 12 1860 when Elias Davidson Pierce and twelve men left Walla Walla and moved quietly and illegally across the Nez Perce reservation. Not long after the illicit prospectors found some promising diggings on Oro Fino Creek, word of the discovery leaked out and the Clearwater rush was on.

By mid-summer 1861, a jerry-built collection of tents and nondescript structures fashioned from hand-hewn logs and whipsawed lumber grandiloquently called itself Pierce City. And why not? The booming community was now the seat of the most populous county in Washington Territory. Soon a second collection of stores, hotels, and saloons took the name Oro Fino City. Located about

three miles from Pierce, Oro Fino City boasted of six restaurants, two hotels, two bakeries, four meat markets, twenty whisky shops, ten gambling saloons, one watchmaker, one bookshop, one barber shop, and three doctors' offices—about seventy-five buildings in all.

During the high water season, an army of gold seekers traveled by steamboat up the Columbia and Snake rivers from Portland to Lewiston where they obtained saddle and pack animals to push on into the interior. Some impatient miners walked to the diggings. Provisions were packed into the Clearwater country from the booming town of Walla Walla or bought from Nez Perce Indians, who began trading with the miners shortly after the first prospectors arrived. Native American farmers living along the fertile bottomlands of the Clearwater, Snake, and Salmon rivers provided eggs, corn, and cattle to the newcomers.

Modern placer mining near Centerville, June 1992.

In the Idaho mining country, as in California and other regions during earlier booms, towns spring up like mushrooms and declined just as quickly when miners stampeded to new diggings. Thousands of disappointed gold seekers followed each new rush. An estimated eight thousand people were in Florence in late June 1862: two weeks later six thousand of them had departed. Oro Fino City was soon abandoned, and it burned to the ground in August 1867. A few of the mining towns, notably Pierce, Silver City, and Idaho City, survived in scaled-down form; most communities of this type did not.

Boom-and-bust cycles continue. Silver production boomed during the late 1970s, when Americans, frightened by an inflation rate that reached eighteen percent, rushed to buy gold and silver as a hedge against further erosion of the dollar's buying power. But when the rate of inflation dropped during the 1980s, so did the price of silver. As late as 1982 Idaho produced 37 percent of the nation's silver, but plunging prices coupled with rising labor costs caused several large companies to close their mines rather than operate them at a loss. When the Bunker Hill Mine and Smelter, Idaho's second largest employer, halted operations in Kellogg in 1981, it idled two thousand workers.

Five years earlier, Kellogg had been a bustling community of five thousand, hub of the fifty mile long silver valley where one quarter of the twenty thousand residents worked in mining. By the mid-1980s Kellogg's population had fallen

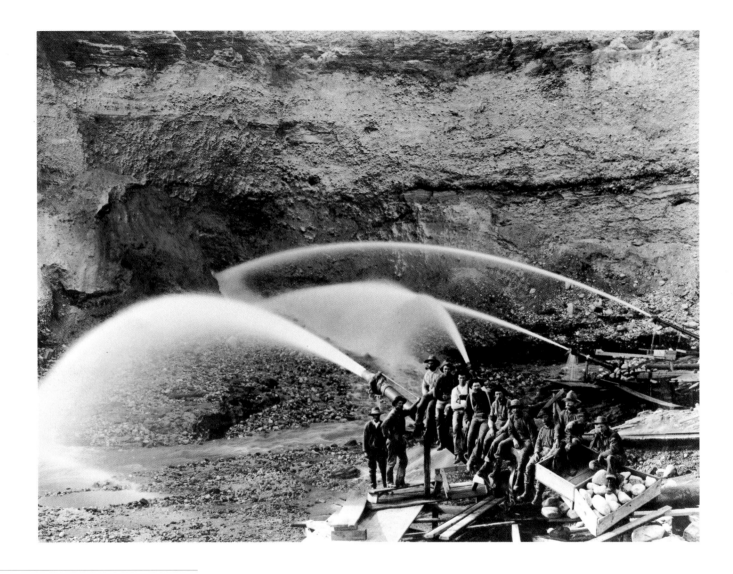

Water cannons and hydraulic mining dramatically reshaped the landscape near Idaho City. Courtesy: Idaho State Historical Society, #1988-A.

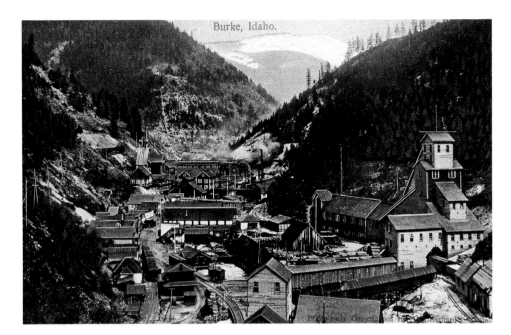

(LEFT)

A color postcard from the early twentieth century shows Burke, near Wallace, as an active mining community. Courtesy: Penrose Memorial Library, Whitman College.

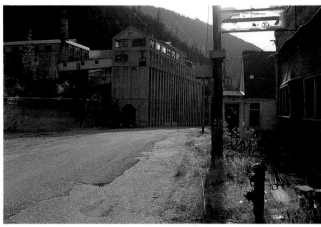

(ABOVE)

Burke as a hard place in October 1992.

below three thousand, and fewer than four hundred people remained employed in the valley's mines. When silver prices rebounded, technological changes had permanently eliminated hundreds of mine and smelter jobs. For some, the Silver Valley appeared to have a future only as a ski resort.

The pattern was much the same in Idaho's timber industry. When it revived in the late 1980s after a bust, innovative technology that included computers and lasers enabled modern sawmills to employ far fewer hands than they had only a decade earlier. Such changes forced many workers to make painful and permanent transitions in their lifestyle. Never again would it be possible to describe Idaho and other states of the Pacific Northwest as a Sawdust Empire. An era had ended forever when sawmills closed in Potlatch, Coeur d'Alene, and similar places.

Several of Idaho's natural resource-based communities turned to tourism for economic salvation, and some have rebuilt from the ashes of their former economy—literally, in some cases. Riggins was a timber town on the Salmon River

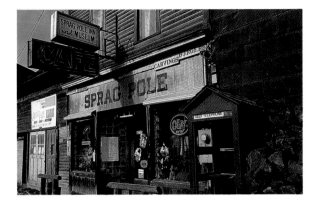

In October 1992 the Sprag Pole Inn and Museum was one of the few surviving businesses in Murray, a one-time placer mining camp that in the booming 1880s was home to several thousand residents.

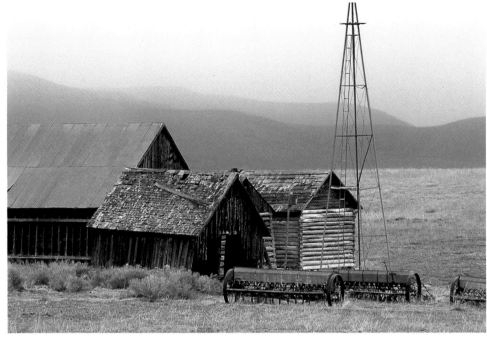

Abandoned farm buildings near Fairfield, April 1995.

until its mill burned in 1982, but river running and outfitting emerged as the community's economic mainstay at the end of the decade.

Riggins was one of the fortunate survivors. Over the years many declining extractive communities never escaped their status as a hard place. Every ghost town, every abandoned mine and farmhouse, and every derelict sawmill and factory testifies to various economic changes that have swept across Idaho during the past century.

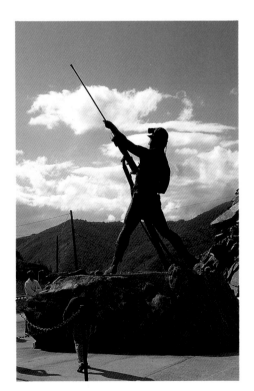

Examples of mining's numerous hard places include the Sunshine Miners' Monument near Kellogg. Photographed in July 1986, it is a poignant reminder of the disaster that occurred near here on May 2, 1972, when carbon monoxide from an underground fire suffocated 91 miners.

IDAHO BY DESIGN

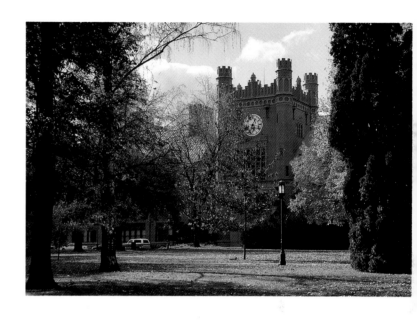

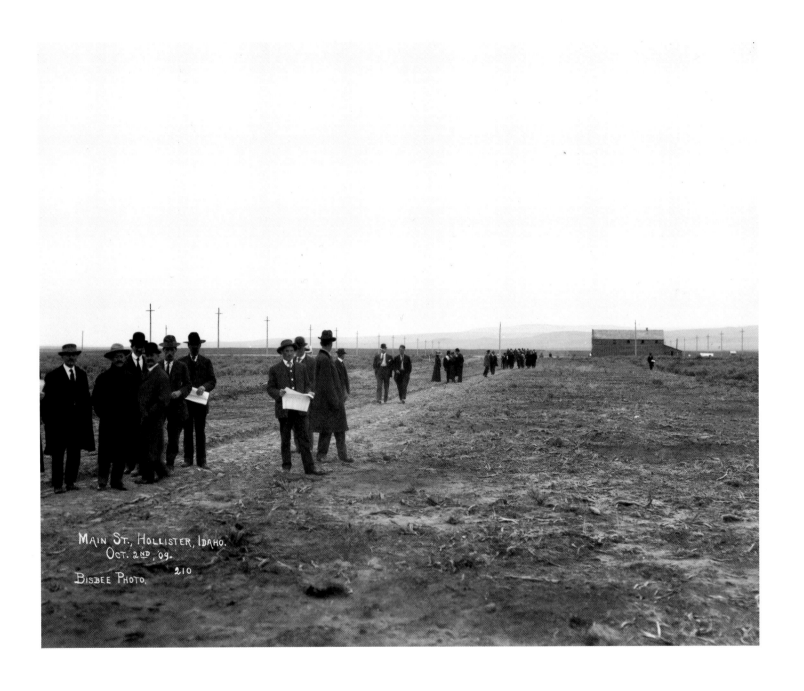

MAIN ST., HOLLISTER, IDAHO.
OCT. 2ND, '09.
BISBEE PHOTO. 210

CHAPTER SEVEN IDAHO BY DESIGN

I ENJOY THE VIEW from my office window on the third floor of the Administration Building at the University of Idaho. In the distance I can see the Moscow Mountains silhouetted against the sky, but it is the foreground that interests me more. Where in nature's scheme there would be a bunch grass prairie typical of the original Palouse countryside, there is instead a tree-shaded common. The look of small-town New England exists here in Idaho because in 1908 the nation's premier landscape architects, the Olmsted Brothers of Massachusetts, designed a master plan for the new state university. Their apparent goal was to give a campus which was less than two decades beyond the raw frontier the instant cache that comes from identification with New England's time-honored landscapes which symbolize historical standing and refinement.

The University of Idaho campus is an example of Idaho by design, a landscape consciously contrived to make a public statement. In this case it speaks to culture and education; by contrast, the Sun Valley landscape makes both economic

and social statements. Less well-known suburban landscapes speak to demographic change and municipal planning, or lack thereof. This much is certain: during the coming years the number of consciously designed landscapes in the Gem State will only increase, though not without the risk of becoming contested terrain during the transformation.

Tensions arise, for instance, when a community that has historically earned its living from timber or mining suffers from hard times and embraces tourism for survival. It may require a modest facelift or even a complete redesign (with impetus coming most often from the business elite) to create the ambiance that appeals to snow skiers and other recreation-minded visitors. Thus a plain vanilla mill- or smeltertown is redesigned to look like an glittery alpine village. This has been the story of Kellogg's transformation since the mid-1980s.

Plans to fabricate and impose a Bavarian-style built environment on the one-time smelter center—following the model of the timber town of Leavenworth, Washington, which transformed itself a few years earlier—proceeded at an uneven pace. Not every Kellogg business accepted the redesign plan, yet creation of these ersatz landscapes is occurring with increasing frequency all over Idaho and the West. Many a downtown redevelopment project chooses an alpine motif, while others seek rebirth as old western villages complete with wooden sidewalks and false-front stores, even where no such frontier architecture was ever discernible.

The old timber town of McCall has successfully transformed itself into a year-round resort without having to resort to "Disneyification," a reference to the power of Disneyland to shape the tourist landscape of the modern American West into little frontierlands or Bavarian fantasylands. McCall was fortunate to have beautiful Payette Lake at its doorstep. At the northern verge of the Camas Prairie the sawmill village of Winchester, on the other hand, was unable to transform itself into a significant tourist destination, even with the creation of Winchester Lake State Park out of the old millpond. As for Sandpoint and Salmon, two communities in the midst of reorientation from a natural-resource based economy to greater reliance on tourist dollars, the proximity to Lake Pend Oreille or to the alluring whitewater of the Salmon River portends both

growth and an increased emphasis on fostering a tourist-oriented municipal landscape.

An even more spectacular sign of the times was Duane Hagadone's $60 million lakeside resort in Coeur d'Alene, which represented an up-to-date blend of big city lifestyle with an Idaho setting rich in natural beauty and outdoor attractions. The expansive resort with its renowned floating golf green became one of the most powerful tourist magnets in northern Idaho.

In the recent past, Coeur d'Alene was basically a lumber town nestled in a very picturesque lakeside setting. Because of its scenic location the community also attracted summer vacationers, primarily from the Spokane area. Steamboat excursions on Lake Coeur d'Alene were the main attraction at the turn of the century. Tourists came in greater numbers and from more distant locations following construction of the Coeur d'Alene Resort. The town boomed not just because of an influx of tourist dollars, but because many people who first came to Coeur d'Alene as vacationers returned to settle as retirees.

One can only guess what the urban landscape of Coeur d'Alene will look like in ten or twenty years, though we Idahoans can probably anticipate the future appearance of a few booming communities by comparing them with places that have already experienced big transformations. I wonder, for example, whether the effervescent combination of lakeside beaches and rapid population growth will transform Coeur d'Alene into the Waikiki Beach of the northern Rocky Mountains. Pictures of Honolulu's famed Waikiki Beach following World War II show a bucolic stretch of sand and palms with only a handful of high-rise hotels visible. Today hotels and condominiums tower above a narrow strip of beach. There are other futurists who envision Coeur d'Alene as the next Lake Tahoe. If bingo parlors on nearby Indian reservations ever became full-scale gambling casinos, this might well determine the future of the Lake City's urban landscape.

The social implications of redesigning Idaho are particularly vivid in the Wood River Valley. Construction of the Sun Valley resort complex in the mid-1930s transformed nearby Ketchum from a declining mining and sheep-raising community into a prosperous center of tourism and outdoor recreation. In more recent years the steady infusion of money changed Ketchum from an upscale

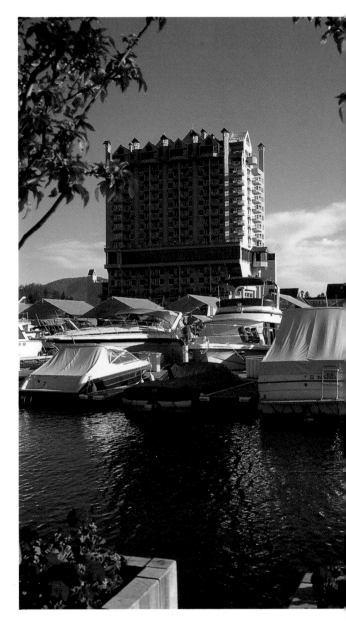

Tourist draw: the Coeur d'Alene Resort in July 1990.

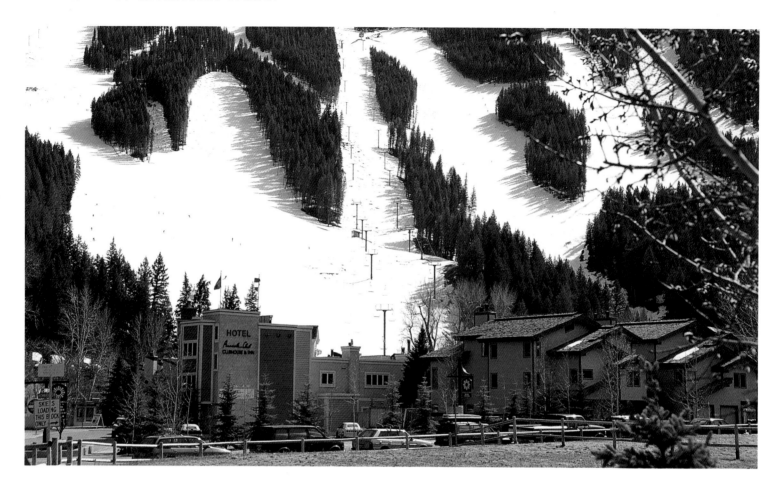

Ski slopes of the Sun Valley-Ketchum area leave their characteristic signature across the land, April 1994. For many Idahoans, winter was once a season to be endured. In 1936 the Union Pacific Railroad opened one of the nation's first modern ski resorts at Sun Valley. Now, because of new recreation facilities and innovative designs in warm and comfortable clothing, winter has become a time of considerable outdoor activity and tourist business.

winter sports playground into a year-round vacation community and finally into an enclave of wealthy permanent residents. Early morning in the modern urban landscape of Ketchum and nearby Hailey and Bellevue reveals a most curious development. A steady stream of headlights extends across the sagebrush plains to the south as service workers who cannot afford to live in the upscale environs of Ketchum drive north from Shoshone and even Twin Falls to jobs catering to the pampered affluent: cleaning their homes, making their beds, and cooking their meals.

The work of designing Idaho can be as commonplace as platting a new town

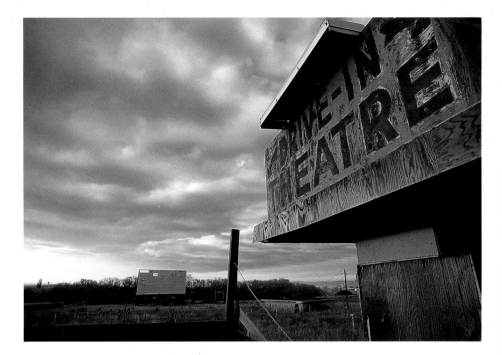

In transition: a drive-in theatre in Grangeville, November 1993.

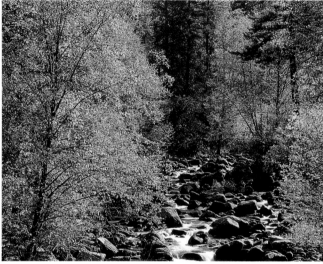

This is the first of three views of Idaho's ever-changing forest landscape: alders resplendent in fall colors and an occasional Douglas fir frame a view of French Creek east of Riggins, October 1994. Forests cover eighty-two percent of the land in the north, but only twenty-eight percent of the much drier southern portion of the state, a highly varied landscpe of hills, eroded slopes, mountains, sagebrush-covered plains, and sandy deserts, all underlain with basalt, the product of volcanism.

or subdivision, and it has been going on since the 1860s. Yet the peculiar spatial relationship that exists today in the Wood River Valley suggests how the process of fabricating new Idaho landscapes may result in all kinds of unintended social and economic consequences. That is why it ranks among the seven landscapes that most define the Gem State.

PERSPECTIVES: LANDSCAPES IN TRANSITION

Every landscape is in transition, but some transitions are both more rapid and more vivid than others. Each time I visit Idaho's main population center I am awed by proliferating subdivisions that each year extend farther into the surrounding countryside, and I wonder when Boise, Nampa, and Caldwell will coalesce into a single urban landscape. In some ways they already have; and I can

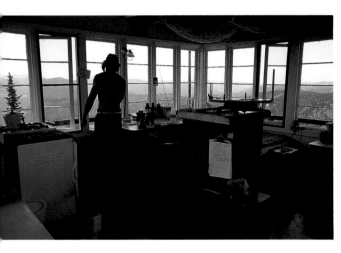

(ABOVE)

Rocky Point, a fire lookout in the Bitterroot Mountains above the Powell Ranger Station, August 1992.

(RIGHT)

Still smoldering in October 1994, this coniferous forest landscape east of McCall was altered by fire the previous summer.

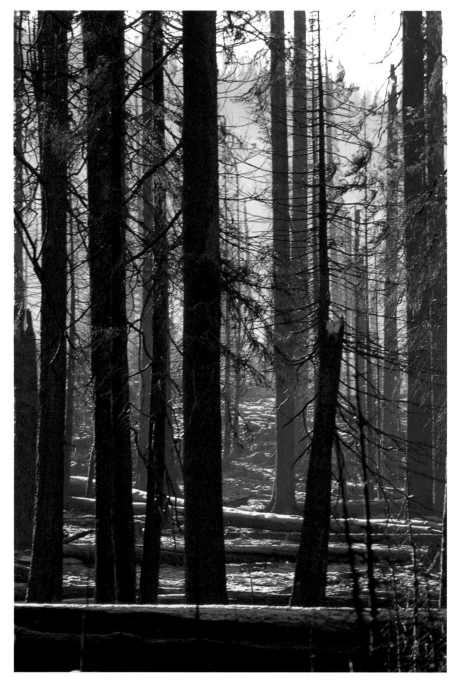

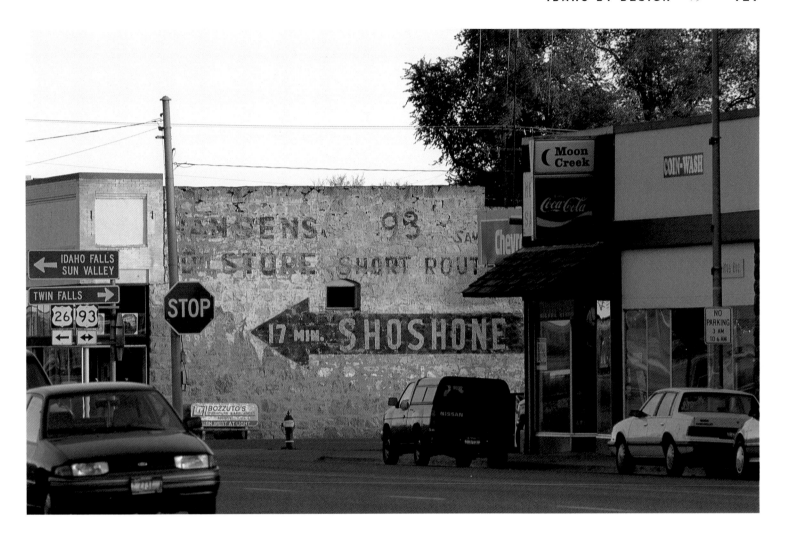

Faded sign in downtown Shoshone in October 1994.

almost visualize the future landscape of metropolitan Boise by looking at present-day Phoenix, Arizona, and its many contiguous communities. The similarities are there for all to see.

But can Idahoans anticipate and thereby avoid the problems of metropolitan Phoenix? Can we maintain the livable environment that made the Boise area attractive in the first place? Or will we do what most westerners have done and ignore the unpleasant changes until we relocate to some less crowded or tainted

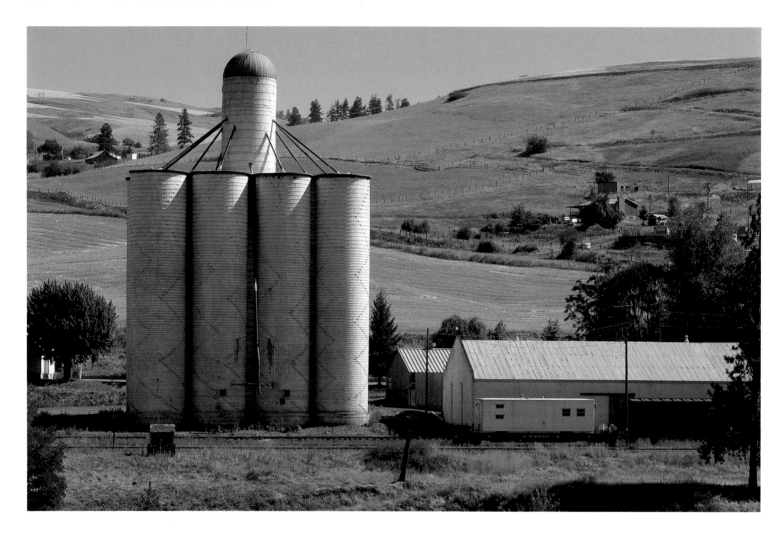

Grain storage facilities at Lenore in the Clearwater Canyon between Lewiston and Orofino. Seen here in August 1988, they have since been replaced by modern concrete facilities.

environment? Our urban West has historically been a no-deposit, no-return landscape that we use up and cast aside. For now, even the most urbanized part of the Gem State remains an appealing environment that contributes to further population growth. If only Idahoans could agree on a landscape designed to harmonize public and private space to *keep* the Gem State both attractive and livable.

THE LAST WORD

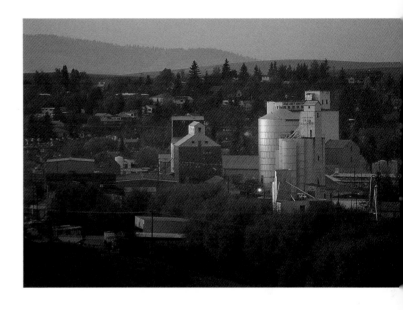

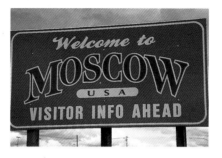

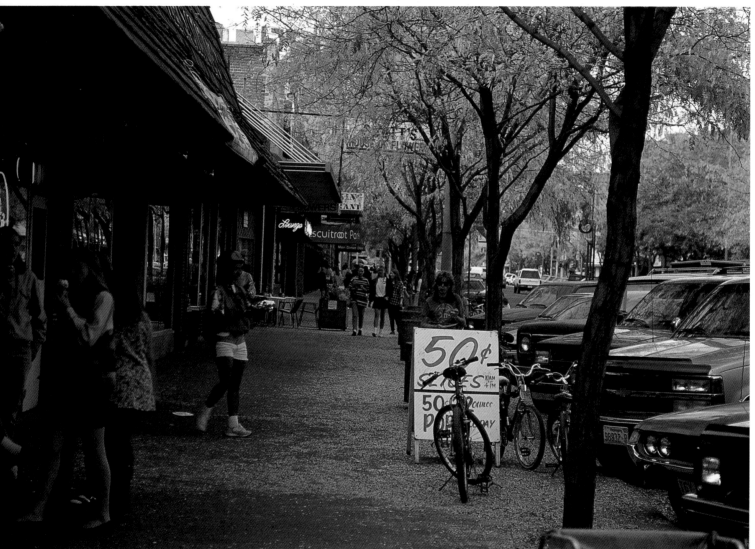

THE LAST WORD

SEVERAL YEARS AGO I had to travel from northern Idaho to Washington, D. C., to evaluate grant proposals for the National Endowment for the Humanities. The trip took me from Spokane to Northwest Airlines' hub in Minneapolis, where I changed to a connecting flight for Washington's National Airport. My assigned seat was close to the right engine of the Boeing 757 jetliner. As we climbed out of the Twin Cities the well-dressed businessman in the adjacent seat asked where I was from, and over the noise I responded simply, "Idaho."

His head snapped back and he refused to talk the rest of the trip. Every attempt to draw him into conversation failed. So unnerving was the strange encounter that I mentioned it to a friend from the NEH who met me at the airport. He pondered a moment and then responded with a grin: "He was probably a government bureaucrat on his way home. Over the roar of the engine he thought you responded, 'I don't know.' Thinking you were weird and on your way to the nation's capital must have unnerved him." This explanation made perfect sense to me.

Actually I do know where I am from, a truth I have sought to make clear with my combination of words and pictures. I am happy to call Idaho home and to celebrate its fascinating landscapes.

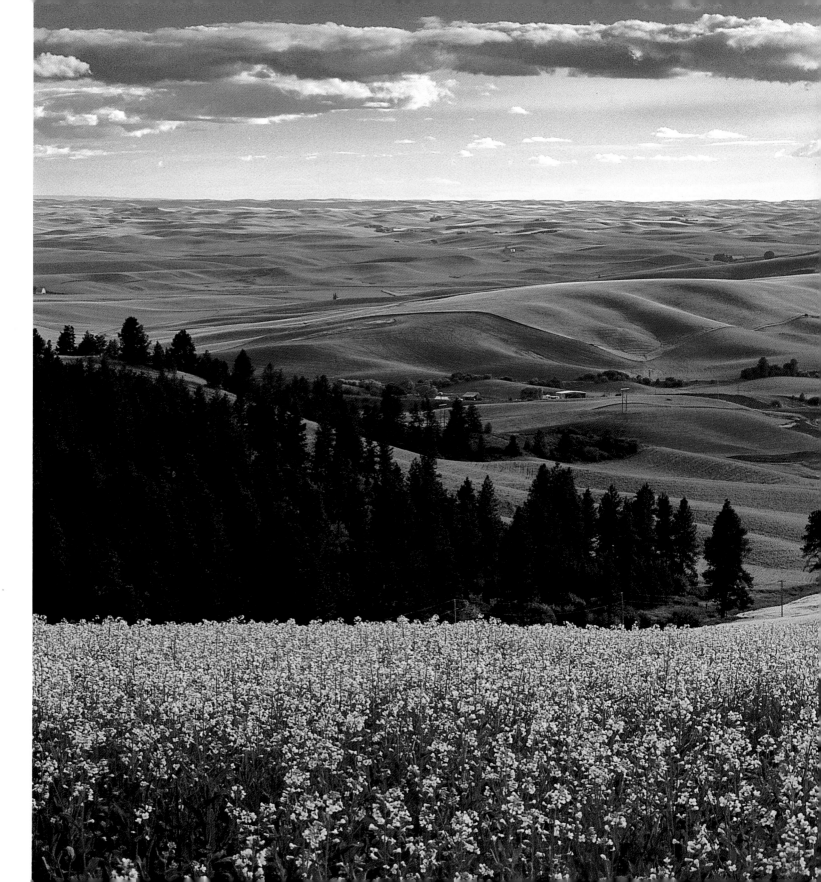

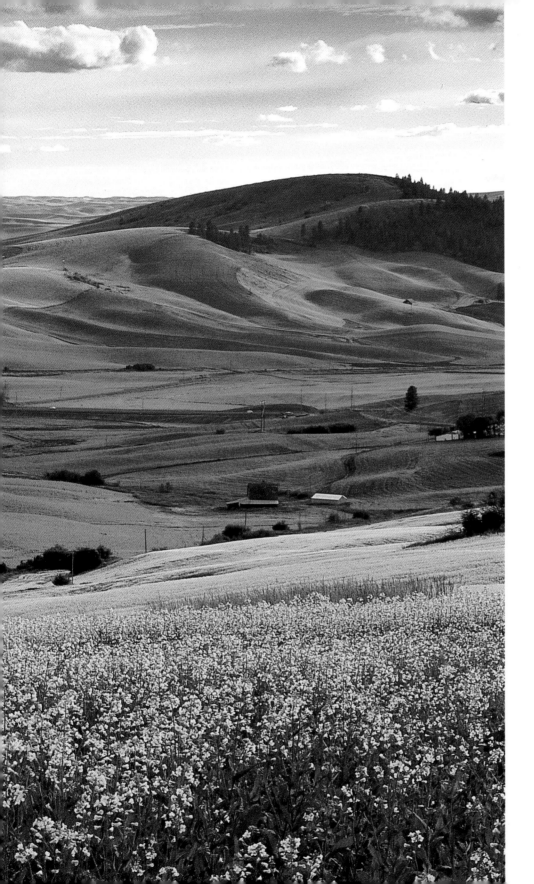

A field of rape (Canola) adds a touch of color to land north of Viola in May 1995.

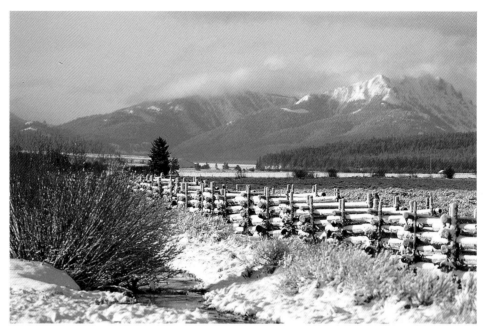

A ranch landscape north of Tetonia in October 1994.

A wooden fence zigzags through the countryside south of Stanley, April 1995.

One of the pleasures of teaching at the University of Idaho has been making friends all over the state. Among the students in my field class, On the Trail of Lewis and Clark, was Bingham County Magistrate Judge Bob Brower, who holds up a bumper sticker reading "Eat Potatoes, Love Longer." This is an appropriate sentiment for Blackfoot, the Gem State's self-proclaimed potato capital. I won't comment on the claimed benefits of eating potatoes except to note that Idaho has the nation's second youngest population (after Utah).

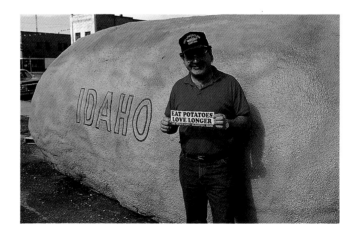

SUGGESTIONS FOR FURTHER READING

THE FOLLOWING BRIEF BIBLIOGRAPHY seeks to guide readers to my sources and to suggest where they might pursue further study of a specific subject. Sources of quotations are listed in the chapter notes that conclude this section. My own photographs used in *So Incredibly Idaho!* have never been published before, but the text includes brief passages adapted and updated from three of my previously published books: *In Mountain Shadows: A History of Idaho* (Lincoln: University of Nebraska Press, 1991); *The Pacific Northwest: An Interpretive History* (Lincoln: University of Nebraska Press, 1989); and *Railroad Signatures Across the Pacific Northwest* (Seattle: University of Washington Press, 1993).

Readers should consult other post-World War II histories of Idaho, including Leonard Arrington, *The History of Idaho*; 2 vols (Moscow: University of Idaho Press, 1994); Merrill D. Beal and Merle W. Wells, *History of Idaho*; 3 vols. (New York: Lewis Historical Publishing Company, 1959); and F. Ross Peterson, *Idaho: A Bicentennial History* (New York: Norton, 1976). Each of these volumes includes suggestions for further reading. See also Merle Wells and Arthur A. Hart, *Idaho: Gem of the Mountains* (Northridge, CA: Windsor, 1985), an illustrated history.

More specialized studies include Jennifer Eastman Attebery, *Building Idaho: An Architectural History* (Moscow: University of Idaho Press, 1991); Louie W. Attebery, *Idaho Folklife: Homesteads to Headstones* (Salt Lake City: University of

Utah Press, 1985); Arthur A. Hart, *Historic Boise: An Introduction to the Architecture of Boise, Idaho, 1863-1938* (Boise: Historic Boise, Inc., 1985); Paul Karl Link and E. Chilton Phoenix, *Rocks, Rails and Trails* (Pocatello: Idaho State University Press, 1994), a historical geography of eastern Idaho; Keith C. Petersen, *Company Town: Potlatch, Idaho, and the Potlatch Lumber Company* (Pullman: Washington State University Press, 1987); Todd Shallat, ed., *Snake: The Plain and Its People* (Boise: Boise State University, 1994); Randy Stapilus, *Paradox Politics: People and Power in Idaho* (Boise: Ridenbaugh Press, 1988); Merle W. Wells, *Gold Camps and Silver Cities: Nineteenth Century Mining in Central and Southern Idaho* (Moscow: Idaho Department of Lands/Bureau of Mines and Geology, 1983); and George Wuerthner, *Idaho Mountain Ranges* (Helena, MT: American Geographic, 1986).

An invaluable source of Idaho history is *Idaho Yesterdays*, the journal of the Idaho State Historical Society. Published quarterly since 1957, its articles provide information on an incredible array of topics. A sampling of articles in *Idaho Yesterdays* that study Gem State landscapes includes Leonard J. Arrington, "Irrigation in the Snake River Valley: An Historical Overview," 30 (Spring/ Summer 1986): 3-11; Leonard J. Arrington, "The Mormon Settlement of Cassia County, Idaho, 1873-1921," 23 (Summer 1979): 36-46; Davis Bitton, "Peopling the Upper Snake: The Second Wave of Mormon Settlement in Idaho," 23 (Summer 1979): 47-52; Hugh Lovin, "Sage, Jacks, and Snake Plain Pioneers," 22 (Winter 1979): 13-15, 18-24; David H. Stratton, "Hells Canyon: The Missing Link in Pacific Northwest Regionalism," 28 (Fall 1984): 2-9; and Earl H. Swanson, Jr., "The Snake River Plain," 18 (Summer 1974): 2-11.

Reference tools include *The Compact Atlas of Idaho* (Moscow: University of Idaho Center for Business Development and Research and Cart-O-Graphics Laboratory, 1983); Richard W. Etulain and Merwin Swanson, *Idaho History: A Bibliography* (Pocatello: Idaho State University Press, 1979); and Milo G. Nelson and Charles A. Webbert, eds., *Idaho Local History: A Bibliography with a Checklist of Library Holdings* (Moscow: University Press of Idaho, 1976). The *Idaho Blue Book*, published biennially by the Secretary of State since 1969, is a most valuable source of information about contemporary Idaho.

Two roadside histories include Cort Conley, *Idaho for the Curious, A Guide* (Cambridge, ID: Backeddy Books, 1982), the best contemporary guide; and Vardis Fisher, *Idaho: A Guide in Word and Picture* (Caldwell, ID: Caxton, 1937). The first of the nation's many Works Progress Administration guides, this remains a classic text.

Among the numerous studies of regional geography and the American landscape, the titles that I found most useful are Grady Clay, *Real Places: An Unconventional Guide to America's Generic Landscape* (Chicago: University of Chicago Press, 1994); Michael P. Conzen, ed., *The Making of the American Landscape* (London: HarperCollins Academic, 1990); Richard V. Francaviglia, *Hard Places: Reading the Landscape of America's Historic Mining Districts* (Iowa City: University of Iowa Press, 1991); Richard V. Francaviglia, *The Mormon Landscape: Existence, Creation, and Perception of a Unique Image in the American West* (New York: AMS Press, 1978); John Brinckerhoff Jackson, *American Space: The Centennial Years: 1865-1876* (New York: Norton, 1972); John Brinckerhoff Jackson, *Discovering the Vernacular Landscape* (New Haven: Yale University Press, 1984); James Howard Kunstler, *The Geography of Nowhere: The Rise and Decline of America's Man-Made Landscape* (New York: Simon & Schuster, 1993); D. W. Meinig, *The Great Columbia Plain: A Historical Geography, 1805-1910* (Seattle: University of Washington Press, 1968); D. W. Meinig, ed., *The Interpretation of Ordinary Landscapes: Geographical Essays* (New York: Oxford University Press, 1979); Allen G. Noble, ed., *To Build in a New Land: Ethnic Landscapes in North America* (Baltimore: The Johns Hopkins University Press, 1992); John R. Stilgoe, *Common Landscape of America, 1580-1845* (New Haven: Yale University Press, 1982); Yi-Fu Tuan, *Topophilia: A Study of Environmental Perception, Attitudes, and Values* (Englewood Cliffs, NJ: Prentice-Hall, 1974); and Denis Wood, *The Power of Maps* (New York: Guilford Press, 1992).

Seven very different studies of a sense of place are Barbara Allen and Thomas J. Schlereth, *Sense of Place: American Regional Cultures* (Lexington: University Press of Kentucky, 1990); Wayne Franklin and Michael Steiner, *Mapping American Culture* (Iowa City: University of Iowa Press, 1992); Winifred Gallagher, *The Power of Place: How Our Surroundings Shape Our Thoughts, Emotions, and Actions*

(New York: Poseidon Press, 1993); John Brinkerhoff Jackson, *A Sense of Place, A Sense of Time* (New Haven: Yale University Press, 1994); David Lamb, *A Sense of Place: Listening to Americans* (New York: Times Books, 1993); Kathleen Norris, *Dakota: A Spiritual Geography* (New York: Ticknor & Fields, 1993); and Deborah Tall, *From Where We Stand: Recovering a Sense of Place* (New York: Alfred A. Knopf, 1993).

Two books that illustrate how landscapes evolve over time are Peter Goin, *Stopping Time: A Rephotographic Survey of Lake Tahoe* (Albuquerque: University of New Mexico Press, 1992); and Michael A. Amundson, *Wyoming: Time and Again* (Boulder: Pruett Publishing, 1991). There is nothing like this yet for Idaho.

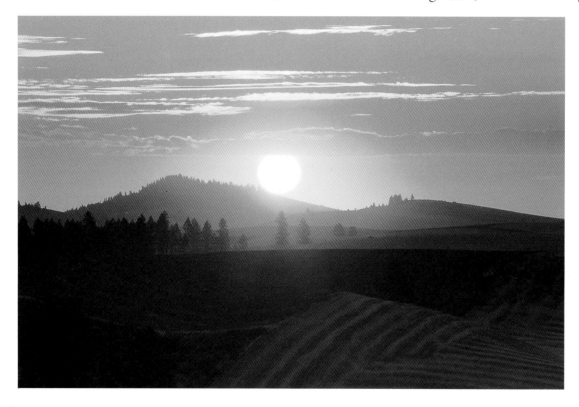

A blazing August sun sets behind a Palouse landmark, Tomer's Butte, which was photographed from Highway 99 south of Troy in 1994.

CHAPTER NOTES

xii Jacques Barzun, *On Writing, Editing, and Publishing: Essays Explicative and Hortatory* (Chicago: University of Chicago Press, 1971): 12.

xvi *Boston Globe*, March 8, 1995, pp. 1, 16. The headline read: "Idaho's Stirs a Feisty Love of Freedom."

xviii Grady Clay, *Real Places: An Unconventional Guide to America's Generic Landscape* (Chicago: University of Chicago Press, 1994).

xix My fascination with the "blue highways" or back roads of America derives from one of my favorite travel books: William Least Heat Moon, *Blue Highways: A Journey into America* (Boston: Little, Brown and Company, 1982).

xx Over the years I've read many books on landscape photography, but when their authors move from technique to philosophy I often lose interest. Too frequently their ruminations strike me as ponderous intellectual justification for the simple act of having fun with a camera. I do admit to being entranced by the ethereal quality of light in the classic landscape paintings by Joseph M. W. Turner.

xx On Riley, see *The Complete Poetical Works of James Whitcomb Riley* (Bloomington: Indiana University Press, 1993).

2 I adapted the description of the New Jersey landscape by Josh

Greenfield, who is quoted by John Leo in *U.S. News and World Report*, May 10, 1993.

3 The map appears on a cover of the *New Yorker*.

4 The best compendium of Idaho misidentification is Tim Woodward, *Is Idaho in Iowa?* (Cambridge, ID: Backeddy Books, 1992).

7 Patrick Gass, *Gass's Journal of the Lewis and Clark Expedition* (Chicago: A. C. McClurg, 1904 reprint of 1811 edition): 145.

12 Gary E. Moulton, ed., *The Journals of the Lewis and Clark Expedition*; vol. 5 (Lincoln: University of Nebraska Press, 1988): 74.

14 Simon Schama, *Landscape and Memory* (New York: Alfred A. Knopf, 1995). On pages 463-98 is an especially insightful discussion of Europe's evolving perception of mountains.

26 *USA Today*, June 2, 1995, p. 2A.

26 A. B. Guthrie, Jr., "Idaho," *Holiday* (May 1954): 131.

41 Jack Donohue, "Joining North and South Idaho," *New West* 10 (April 1919): 46.

43 Information on the naming of Idaho is from the *Congressional Globe*, 37th Congress, 3d Session (March 3, 1863): 1509.

51 The description of mail day is from William Armistead Goulder, *Reminiscences: Incidents in the Life of a Pioneer in Oregon and Idaho* (Moscow: University of Idaho Press, 1989 reprint of 1909 edition): 216.

51-52 Goulder, *Reminiscences*, pp. 217-218.

58 John Steinbeck, *Travels with Charley: In Search of America* (New York: Viking Press, 1961): 81.

58 *USA Today*, June 2, 1995, p. 2A.

60 Donald Jackson and Mary Lee Spence, eds., *The Expeditions of John Charles Fremont*; vol. 1 (Urbana: University of Illinois Press, 1970 reprint of 1845 edition): 520.

62-63 Chief Joseph's Own Story (Fairfield, WA: Ye Galleon Press, 1972 reprint of 1879 article): 16-17.

63 Ray Stannard Baker, "Destiny and the Western Railroad," *Century Magazine* 75 (April 1908): 892-4.

64 John Hailey, *The History of Idaho* (Boise: Syms-York, 1910): 351.

65 Baker, "Destiny and the Western Railroad," p. 894.

65 On the allurements of Guyer Hot Springs, see *World's Pictorial Line* (Omaha: Union Pacific Railway, 1893).

66 On the Hayden Lake resort, see *Electric Railway Journal*, 33 (January 30, 1909): 364-366; and Spokane, Portland & Seattle Railway, *Public Timetable* (June 17, 1916): 14.

66 On the appeal of Shoshone Falls, see *World's Pictorial Line*.

69 *Moscow-Pullman Daily News*, May 19, 1995, p. 4A.

69 Samuel Parker, *Journal of an Exploring Tour Beyond the Rocky Mountains* (Minneapolis: Ross & Haines, 1967 reprint of 1838 edition): 107.

76 The term "empty quarter" comes from Joel Garreau's fascinating study, *The Nine Nations of North America* (Boston: Houghton Mifflin, 1981): 287-327.

85 The term "hard places" comes from Richard V. Francaviglia, *Hard Places: Reading the Landscape of America's Historic Mining Districts* (Iowa City: University of Iowa Press, 1991).

97 For this appealing explanation I am indebted to my friend Richard Emmerson, formerly of the National Endowment for the Humanities and now a member of the English Department at Western Washington University.

INDEX